The Art of
IRVIN BOMB

Irvin Bomb was born in New York City in 1967. He graduated from George Washington University with a bachelor's degree in fine art where he was awarded the Morris Lewis Painting Fellowship. While living in Washington D.C., Irvin was commissioned to paint the portrait of President Theodore Roosevelt which is now on public display in the permanent collection of the United States Naval Museum at 701 Pennsylvania Ave. Washington, D.C. Upon returning to New York City, Irvin did commercial artwork for Marvel & Acclaim comics. From there, Irvin moved on to paint erotic pin-ups for numerous adult magazines such as Penthouse, High Society, Leg Sex, Big Butt, Black Tail, & Cheeks to name but a few.

He currently resides in New York City, and his artwork can be seen on his website at http://www.nastyart.com. If you wish to contact Irvin his email address is irvin@nastyart.com.

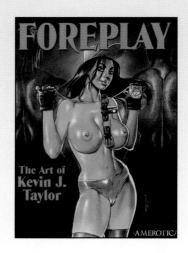

Also available:
Evolution, $19.95
Foreplay, $18.95
Just Bloomed, $11.95

(add $3 P&H 1st item, $1 each addt'l)

We have over 150 graphic novels in print, write for our color catalog:
NBM
555 8th Ave. Suite 1202
New York, NY 10018
www.nbmpublishing.com

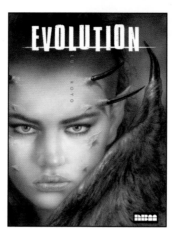

ISBN 1-56163-305-4
© 2001 Irvin Bomb
Printed in China
Design by Ortho, cover design by Joe Kaufman

5 4 3 2 1

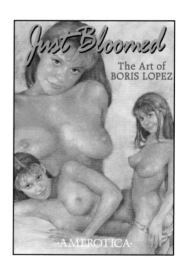

Amerotica is an imprint
and trademark of

NANTIER ◦ BEALL ◦ MINOUSTCHINE
Publishing inc.
new york

The Art of
IRVIN BOMB

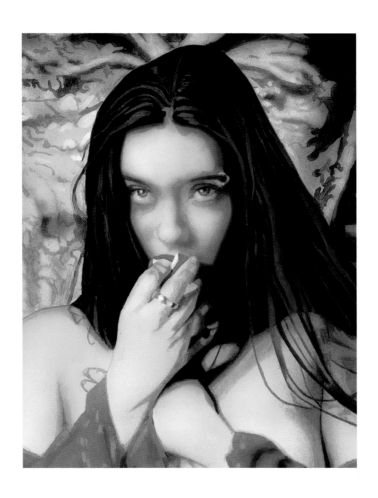

·AMEROTICA·

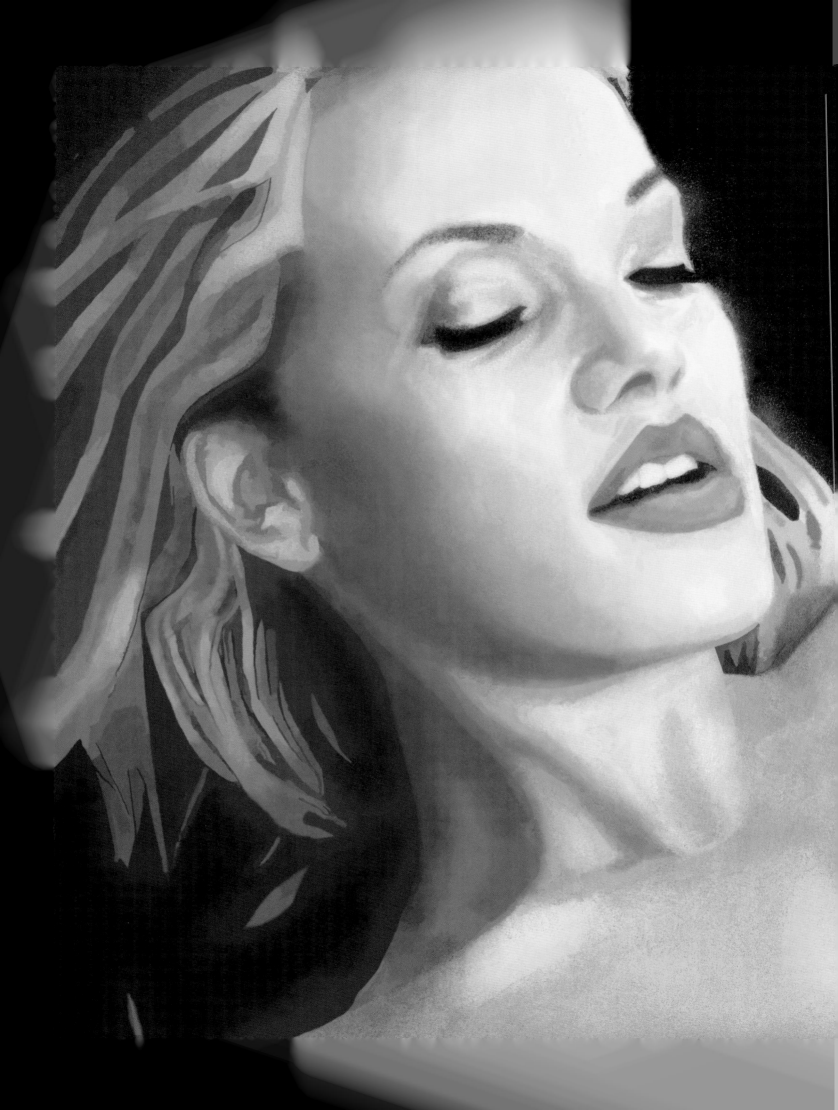

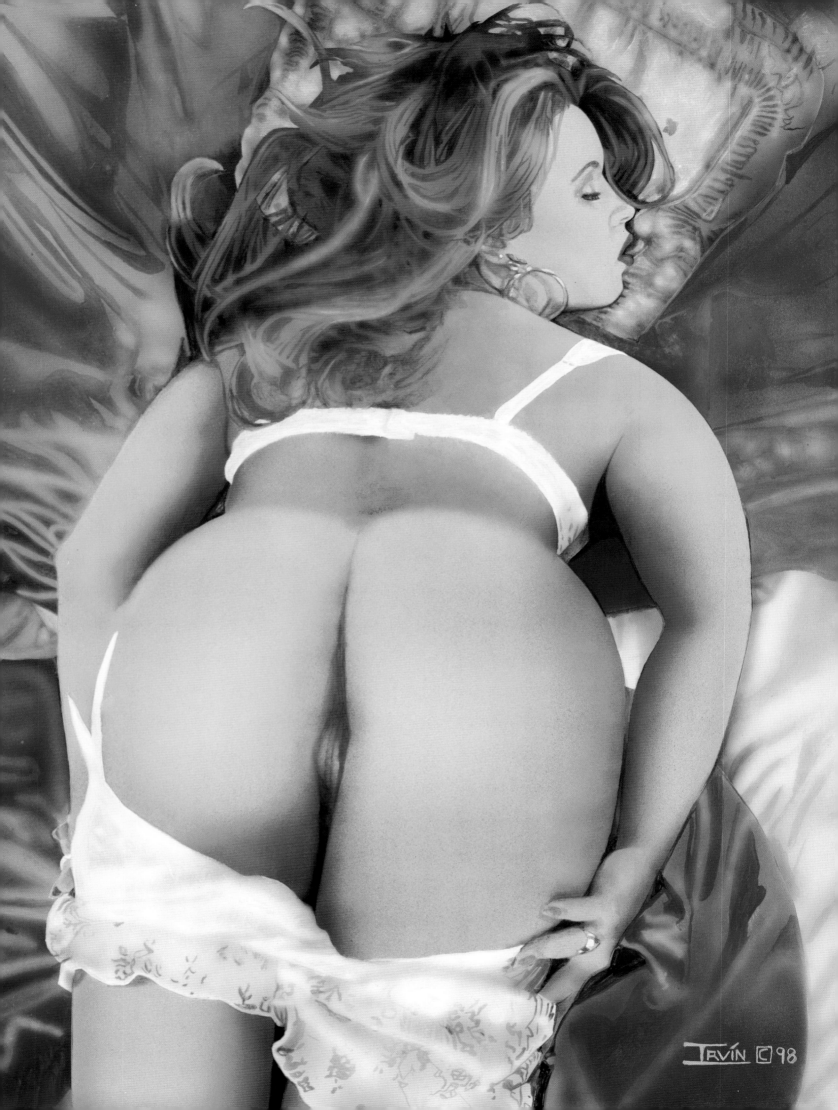

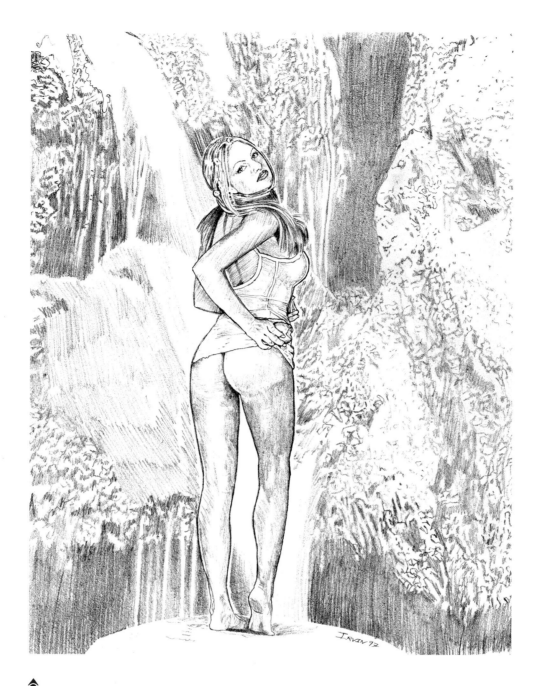

'**Waterfall**' Pencil on Paper - 21 X 28 cm. - 1997

'**Jungle Woman**' Watercolor on Paper - 27.5 X 37.5 cm. - 1997

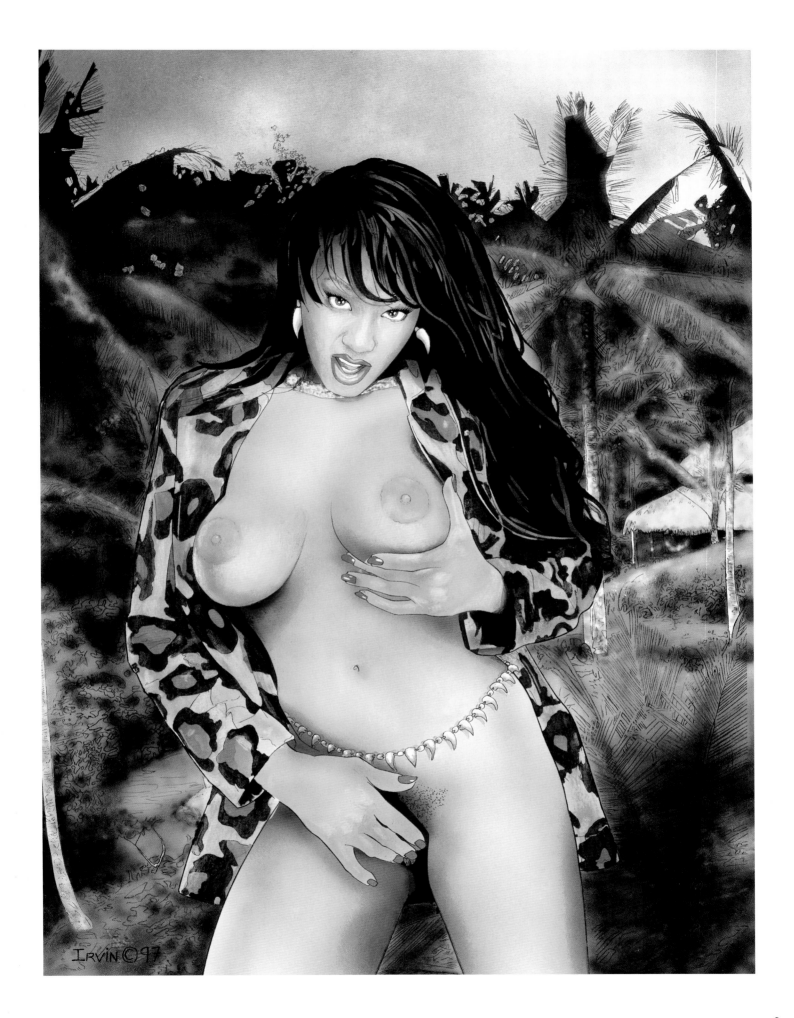

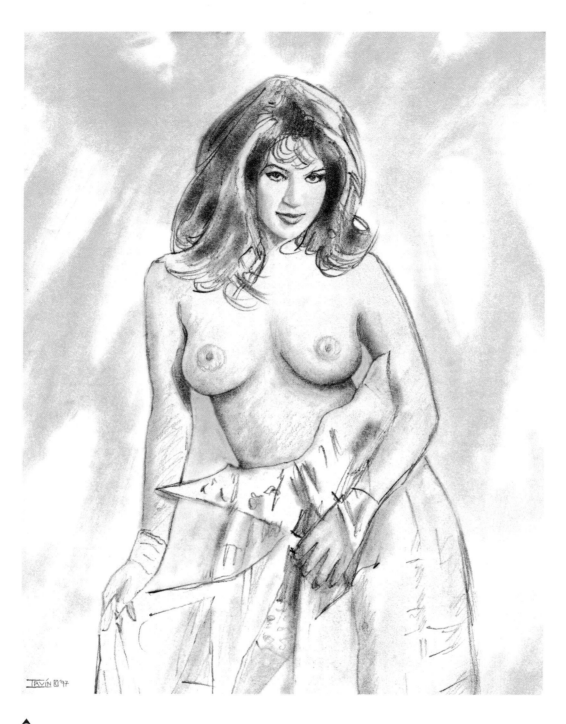

'Shear' Pencil on Paper - 17 X 22 cm. - 1997

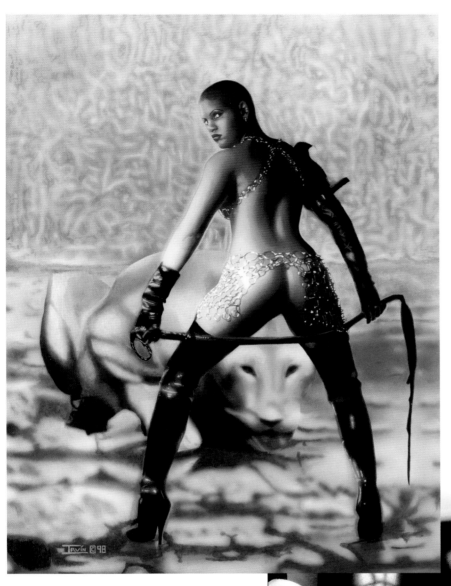

◀●
'Lady Kayla I -Crack of the Whip'
Oil on Wood Panel – 30 X 40 cm. - 1998

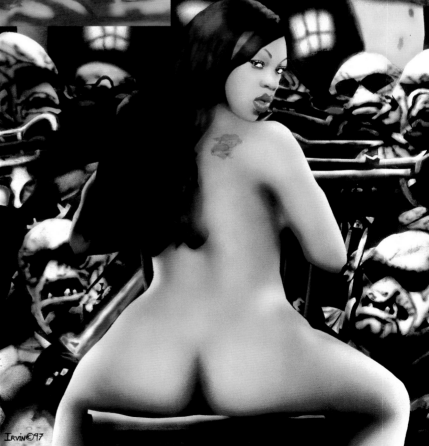

●▶
'Final Command' Acrylic on
Paper - 27.5 X 37.5 cm. - 1997

11

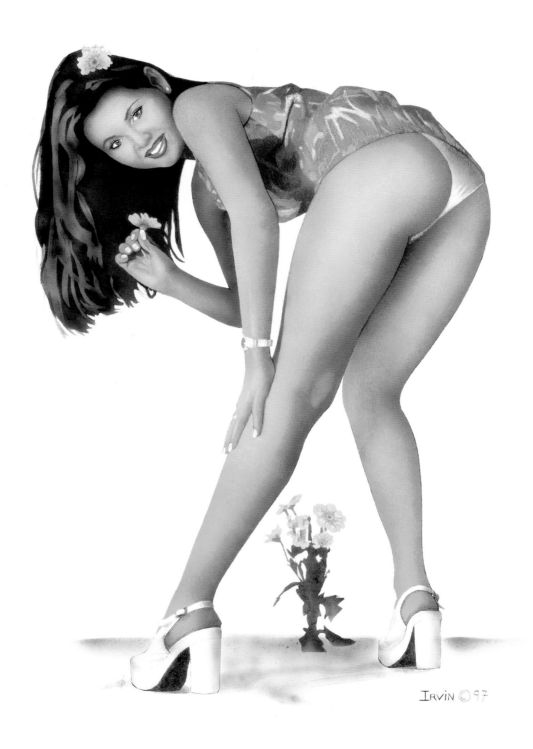

'Flower Girl' Watercolor on Paper - 27.5 X 37.5 cm - 1997

'Crawling Girl' Pen & Ink on Paper - 21 X 27.5 cm. - 1997

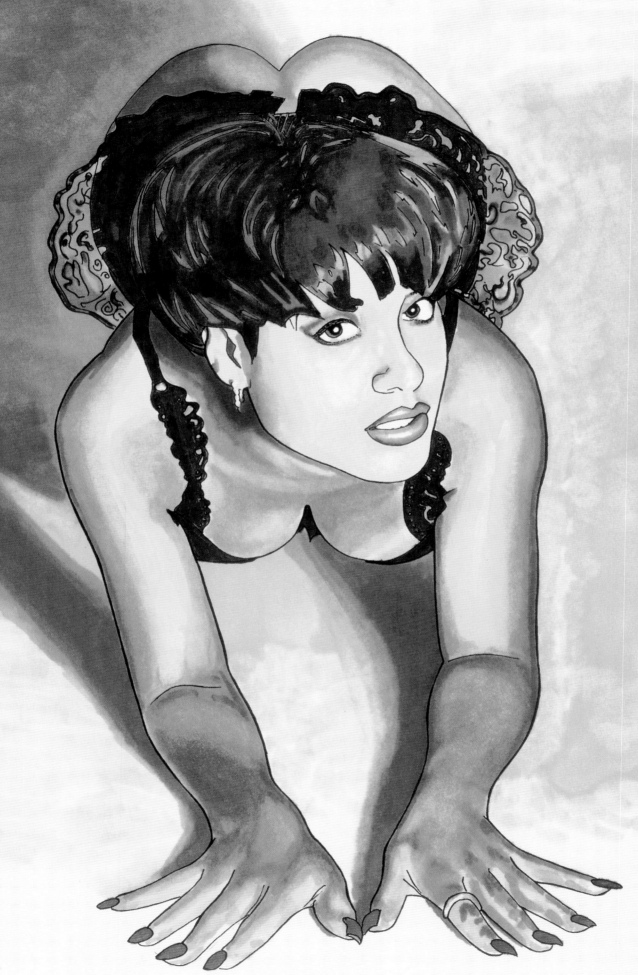

Irvin©97

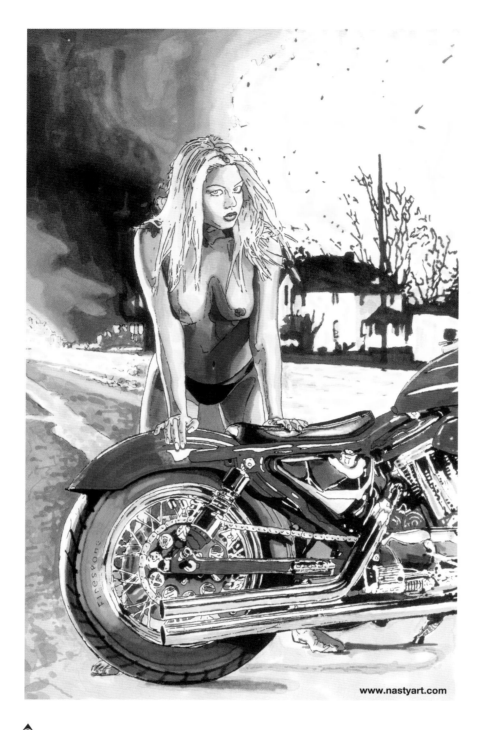

www.nastyart.com

⬆
'Cycle Girl' Pen & Ink on Paper - 17 X 27.5 cm. - 1997

❱
'Bath Girl I' Pencil on Paper - 8 X 10.5 cm. - 1997
'Bath Girl II' Pencil on Paper - 8 X 10.5 cm. - 1997
'Bath Girl III' Pencil on Paper - 8 X 14.5 cm. - 1997
'Bath Girl IV' Pencil on Paper - 8 X 8.5 cm. - 1997

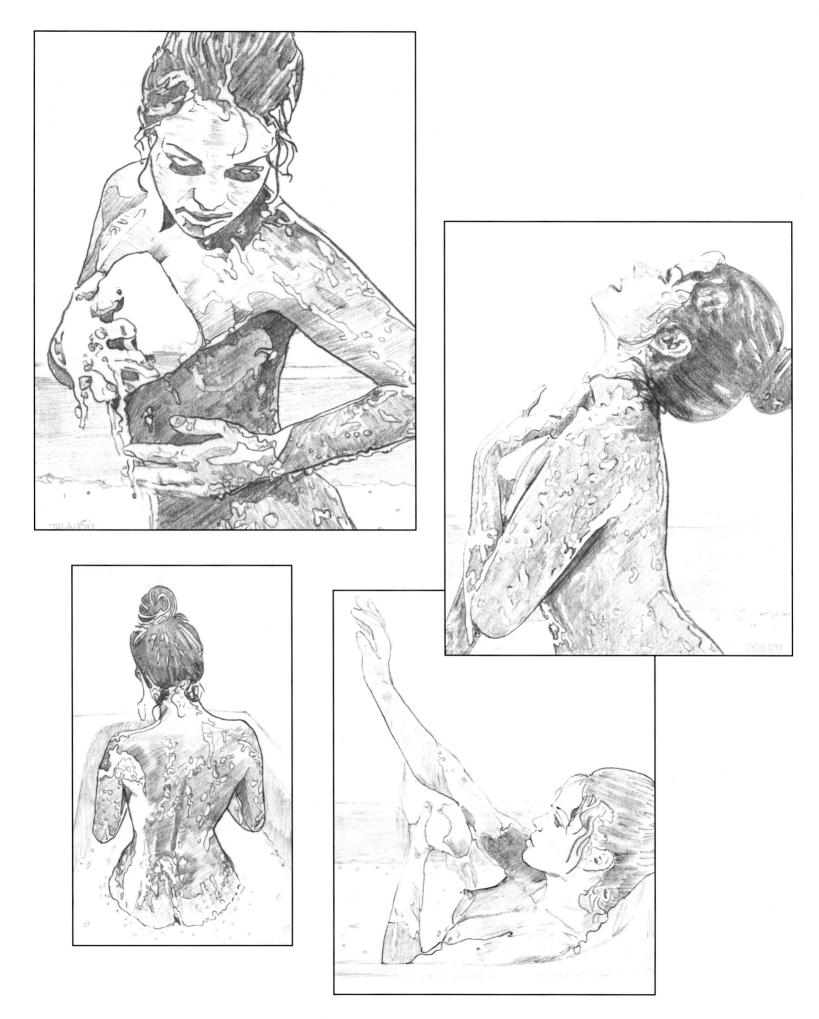

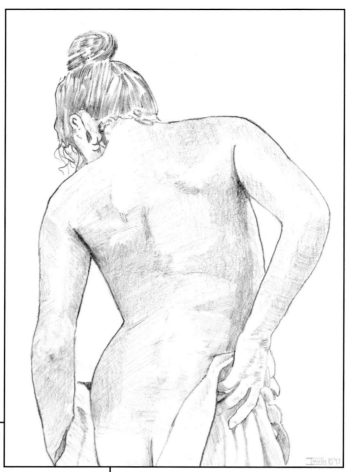

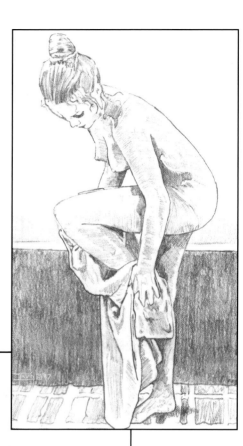

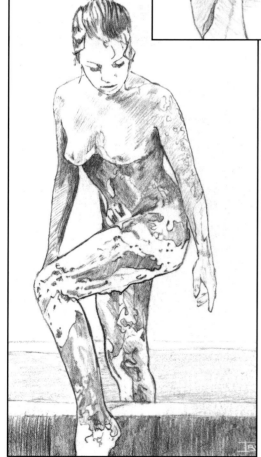

'Bath Girl V' Pencil on Paper - 8 X 12.5 cm. - 1997
'Bath Girl VI' Pencil on Paper - 8 X 10.5 cm. - 1997
'Bath Girl VII' Pencil on Paper - 8 X 14.5 cm. - 1997
'Bath Girl VIII' Pencil on Paper - 8 X 14.5 cm. - 1997

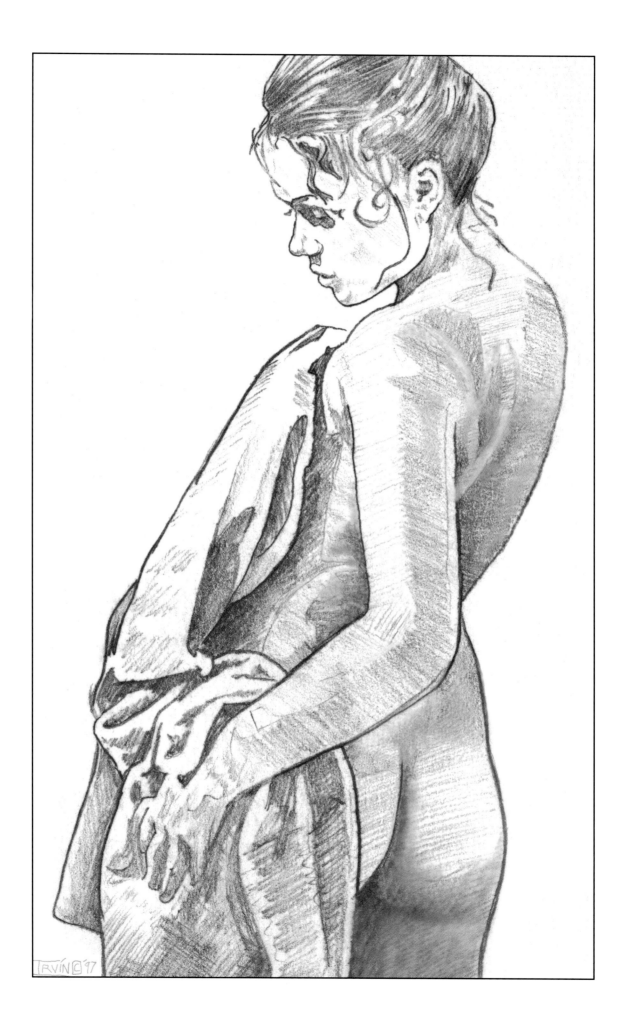

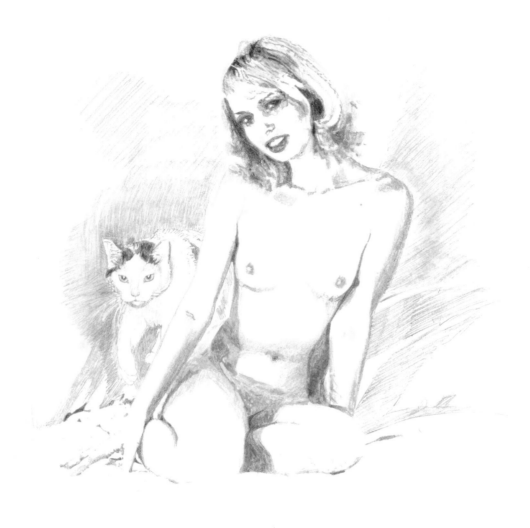

▲
'Girl With Blinky' Colored Pencil on Wood Panel - 23 X 30.5 cm. - 2001
This painting is dedicated to the loving memory of Blinky.

◆▶
'Girl with Lizzie' Oil on Wood Panel – 30 X 40 cm. - 1998
This painting is dedicated to the loving memory of Lizzie.

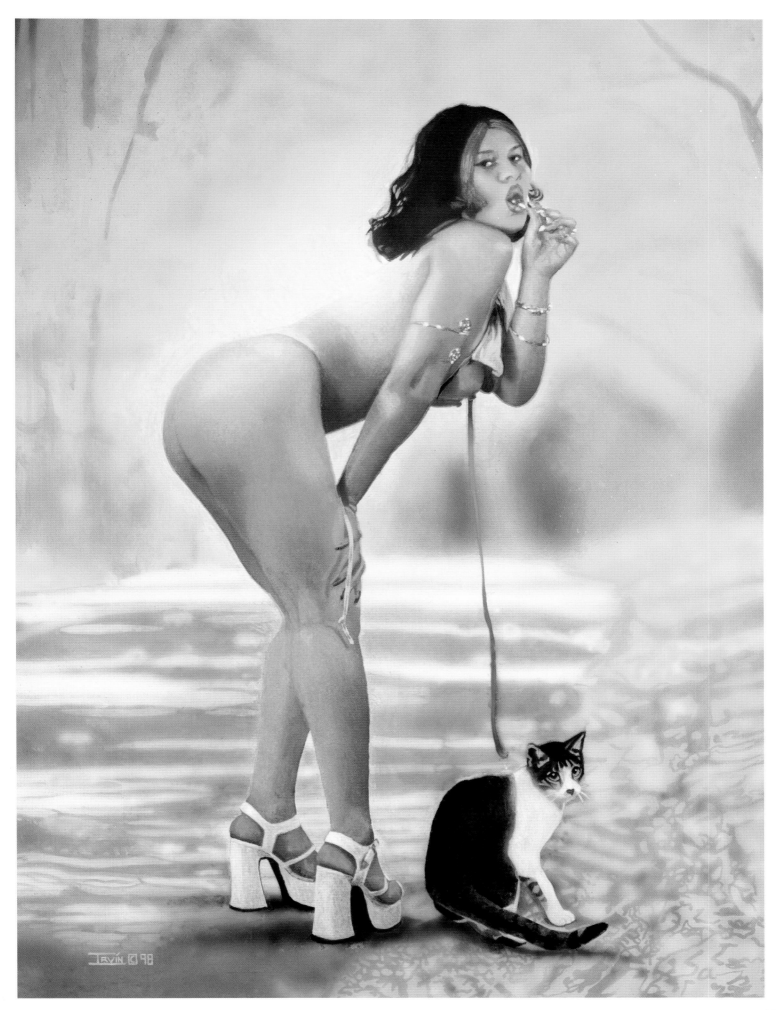

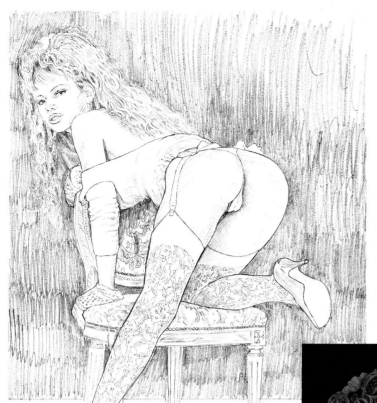

⬧ 'White Stockings -Study'
Pencil on Paper - 21 X 28
cm. - 1997

◆▶ 'White Stockings'
Watercolor on Paper -
27.5 X 37.5 cm. - 1997

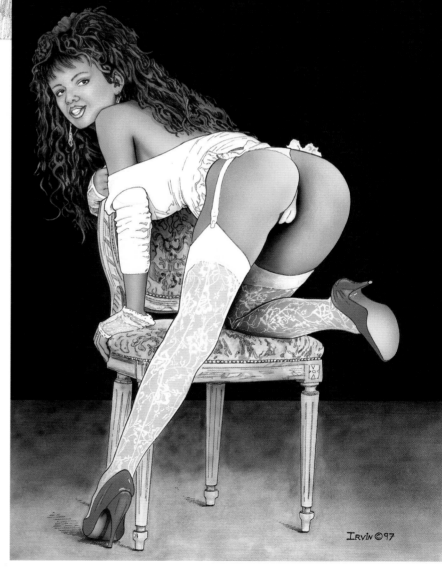

◆▶ 'Cutie' Watercolor on Paper - 27.5 X 42.5 cm. - 1997

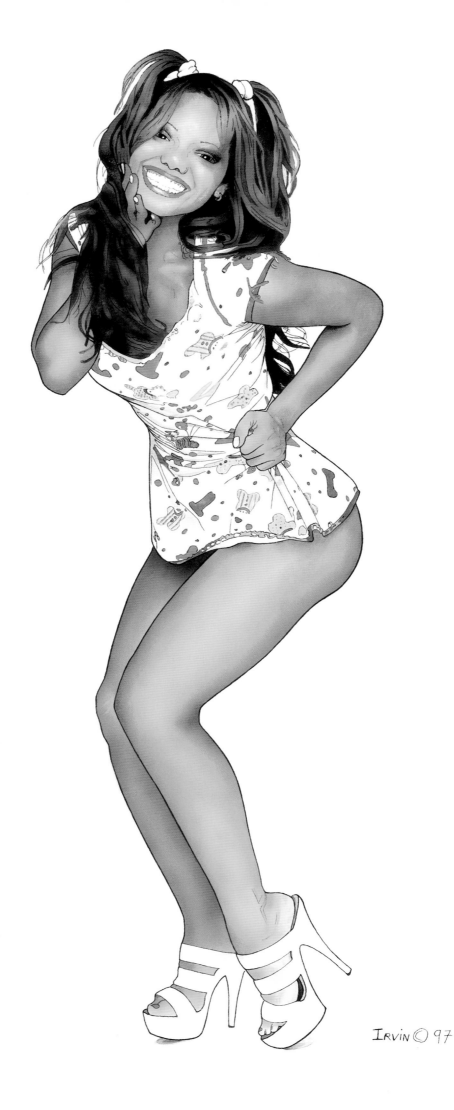

Irvin © 97

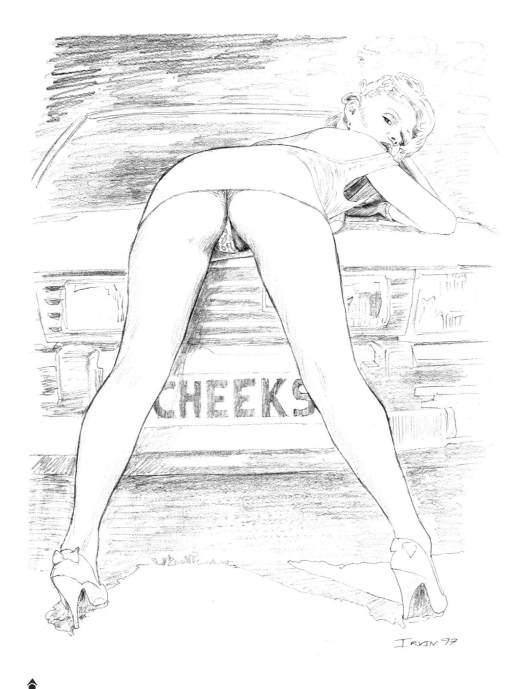

'**High Speed -Study**' Pencil on Paper - 21 X 28 cm. - 1997
As you can see from the study, this was originally commissioned for Cheeks magazine. Then they decided to run it in Big Butt magazine (notice how they had me increase the size of her butt).

'**High Speed**' Acrylic on Paper - 27.5 X 37.5 cm - 1997

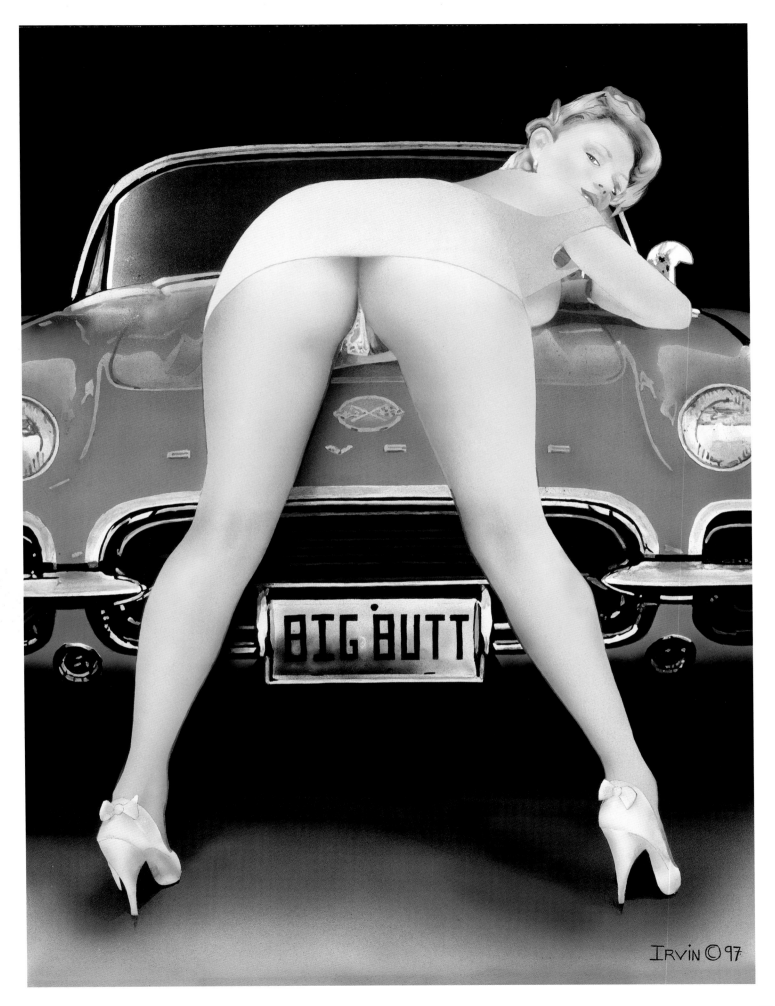

Irvin © 97

23

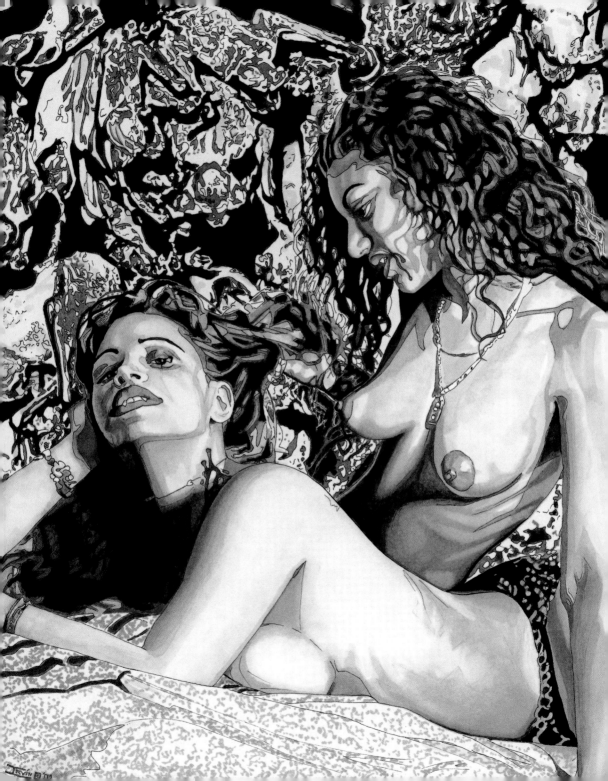

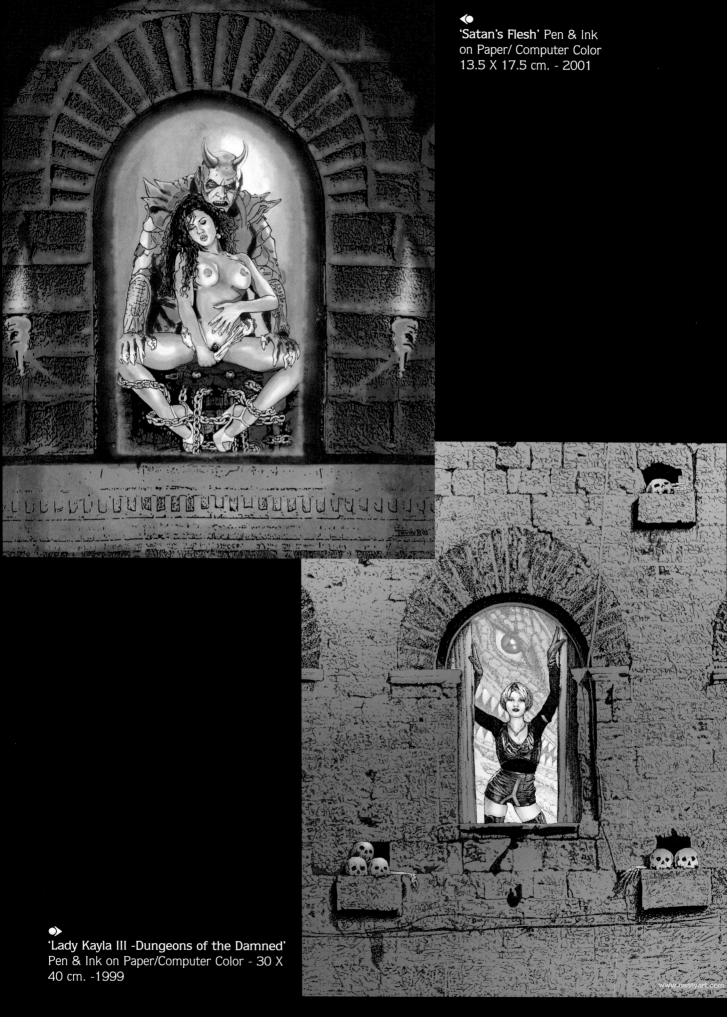

'Satan's Flesh' Pen & Ink
on Paper/ Computer Color
13.5 X 17.5 cm. - 2001

'Lady Kayla III -Dungeons of the Damned'
Pen & Ink on Paper/Computer Color - 30 X
40 cm. -1999

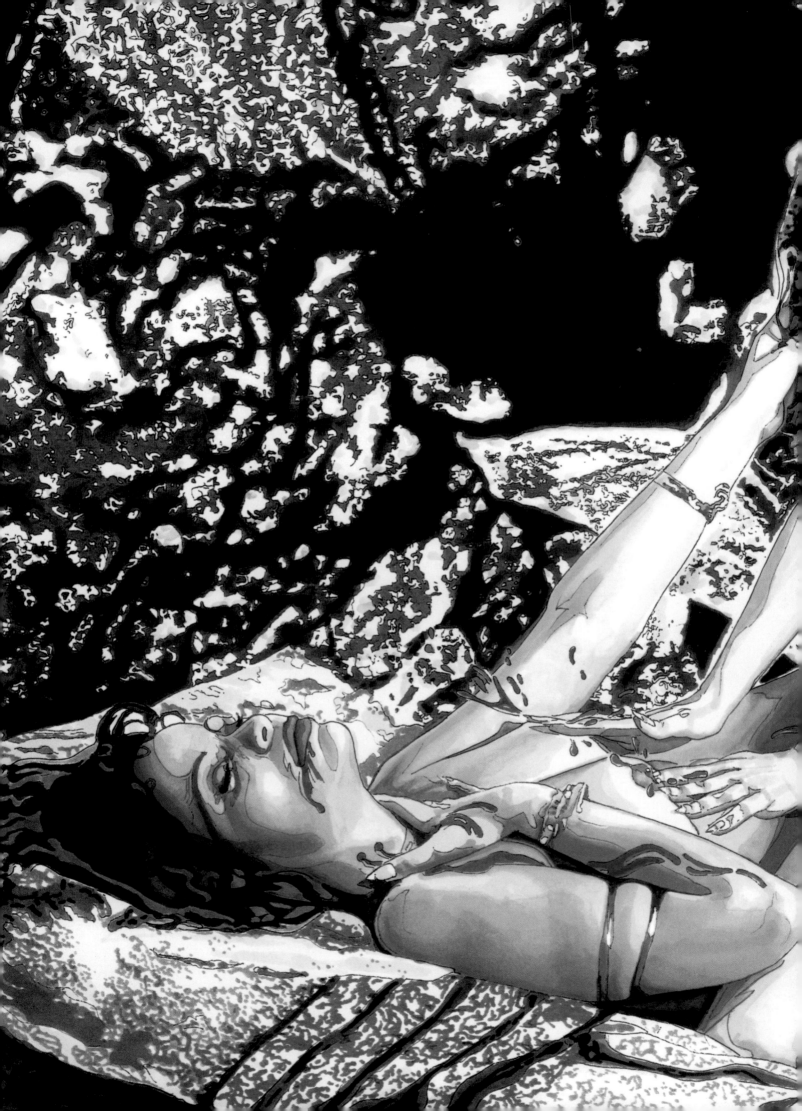

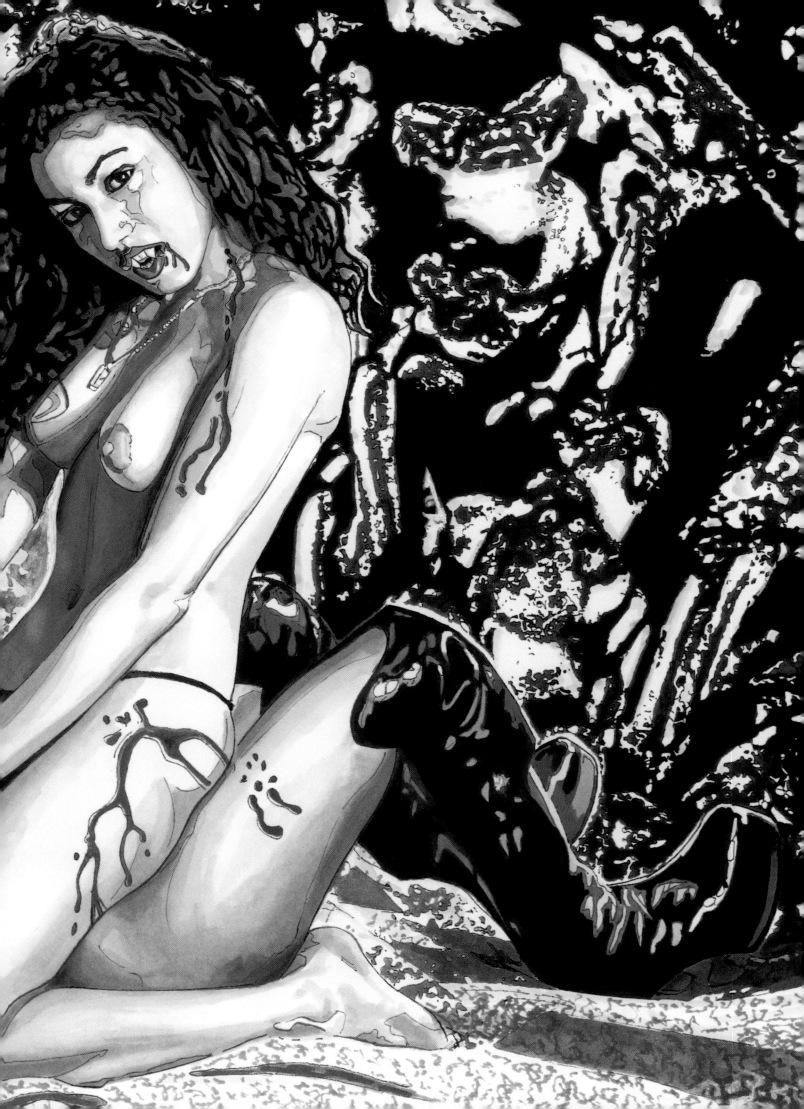

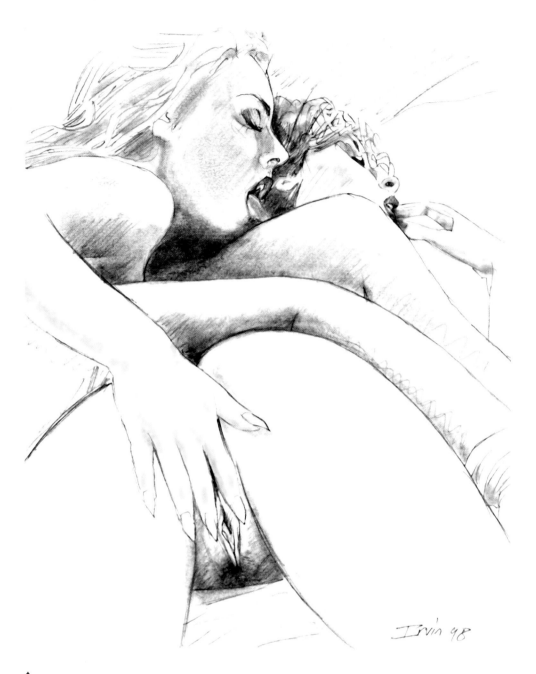

⬥
'Thirst Quencher' Pencil on Paper - 21 X 28 cm. - 1998

◗
'Blood Lust III' Pen & Ink on Paper - 19 X 25 cm. - 2001

◖
'Blood Lust VI' Pen & Ink on Paper - 36.5 X 27.5 cm. - 2001

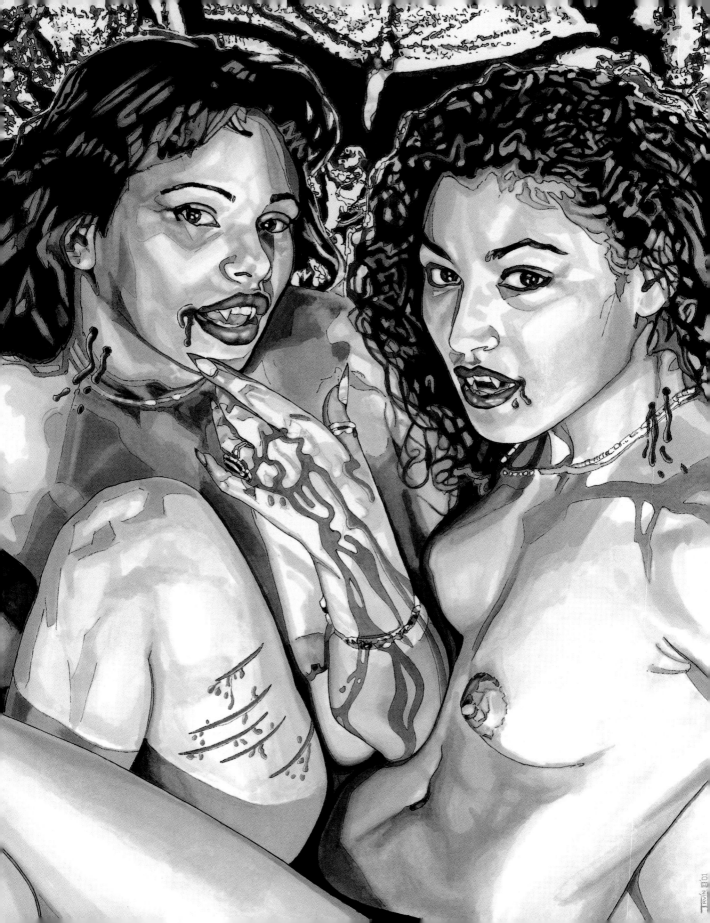

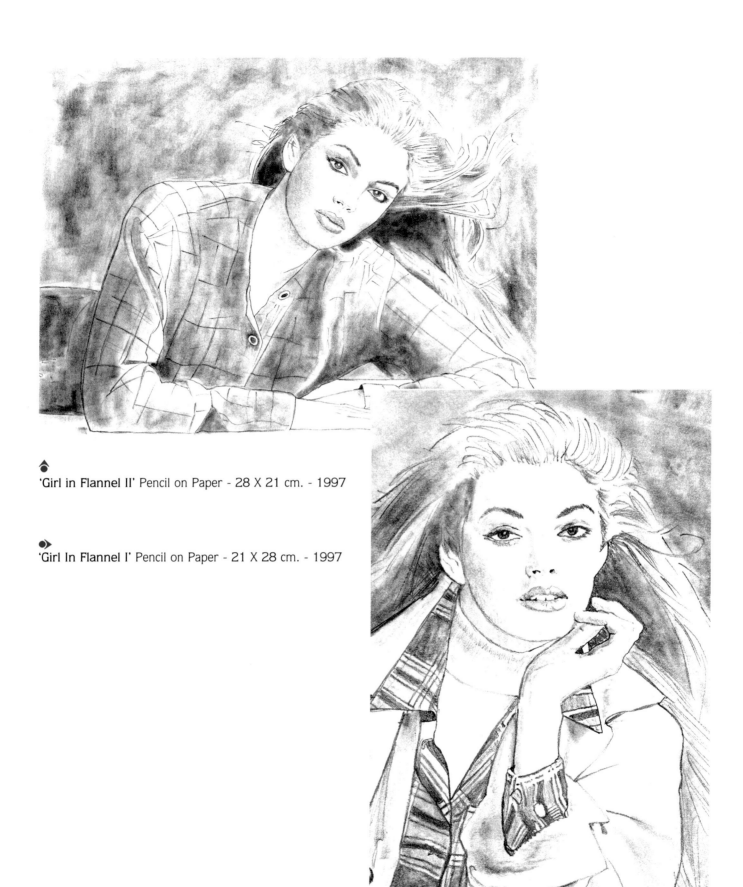

♠
'Girl in Flannel II' Pencil on Paper - 28 X 21 cm. - 1997

◗
'Girl In Flannel I' Pencil on Paper - 21 X 28 cm. - 1997

◗ 'Girl In Hat' Pencil on Paper - 21 X 28 cm. - 1997

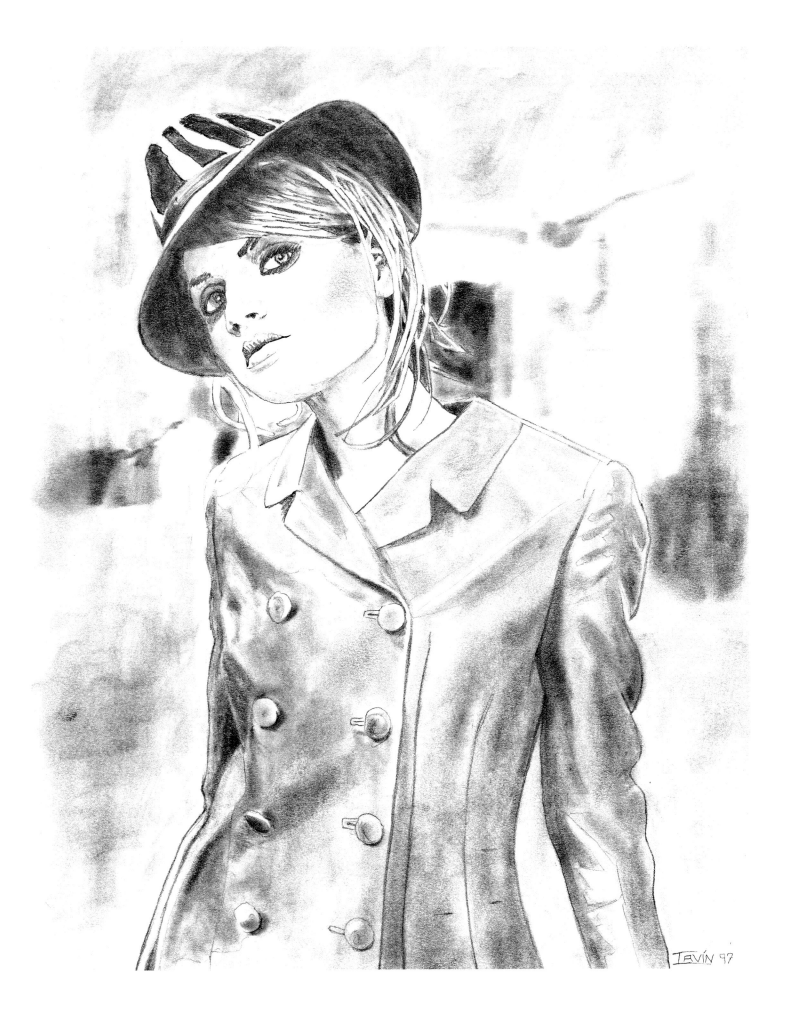

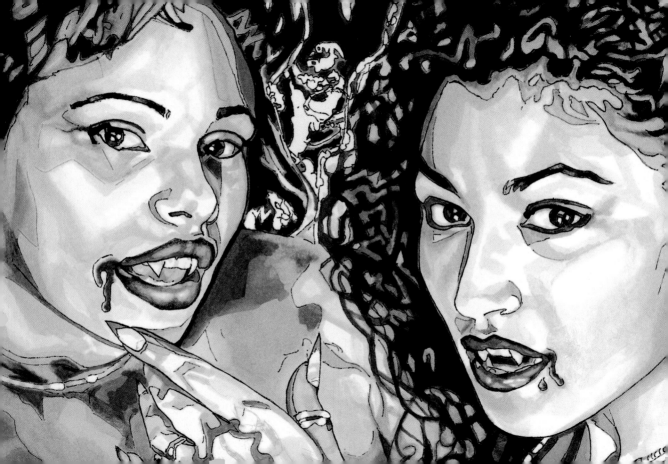

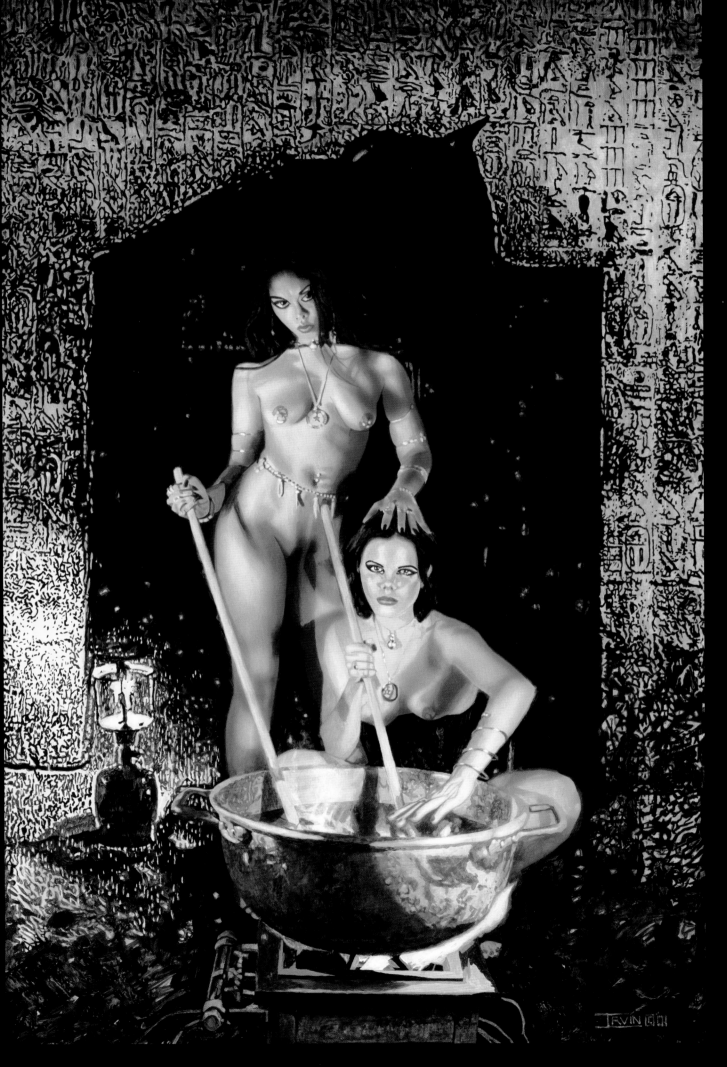

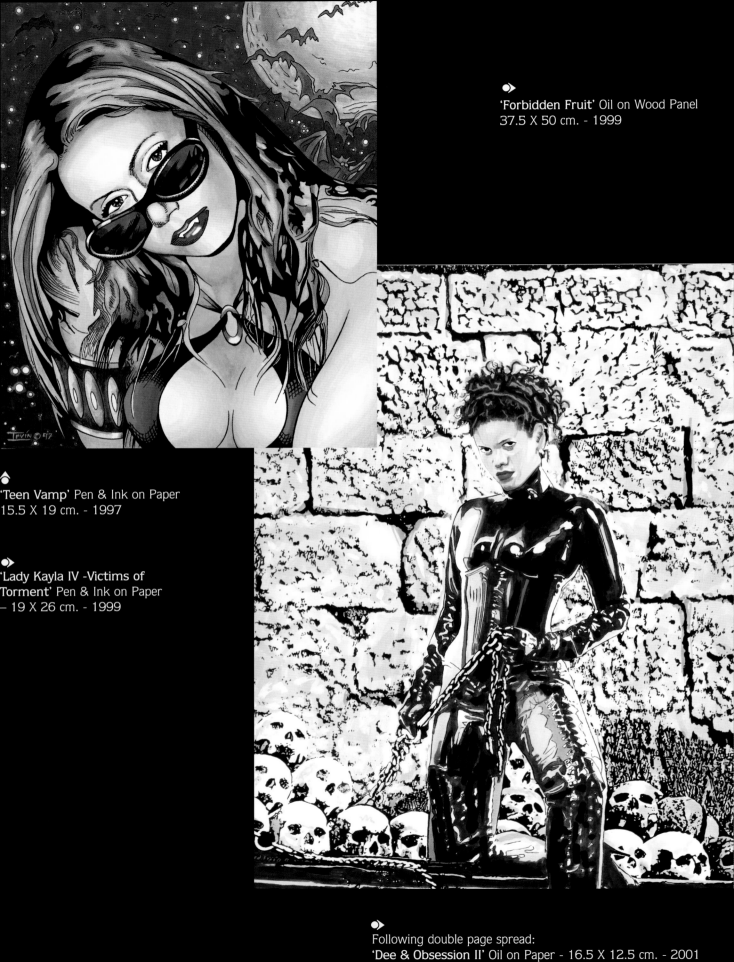

'Forbidden Fruit' Oil on Wood Panel
37.5 X 50 cm. - 1999

'Teen Vamp' Pen & Ink on Paper
15.5 X 19 cm. - 1997

'Lady Kayla IV -Victims of
Torment' Pen & Ink on Paper
— 19 X 26 cm. - 1999

Following double page spread:
'Dee & Obsession II' Oil on Paper - 16.5 X 12.5 cm. - 2001

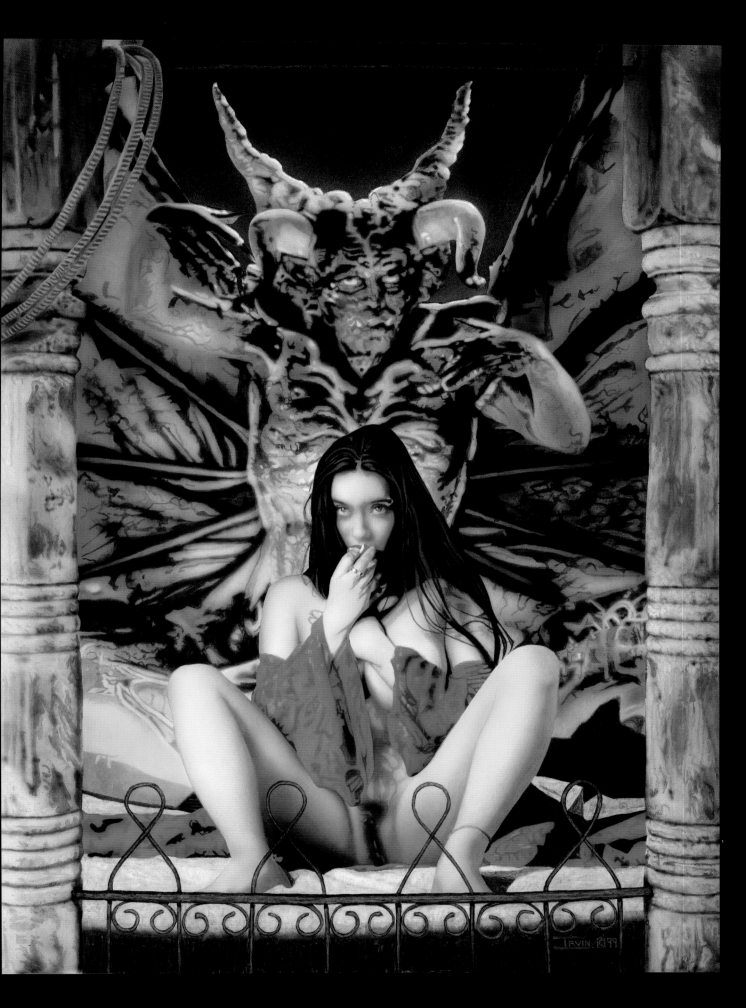

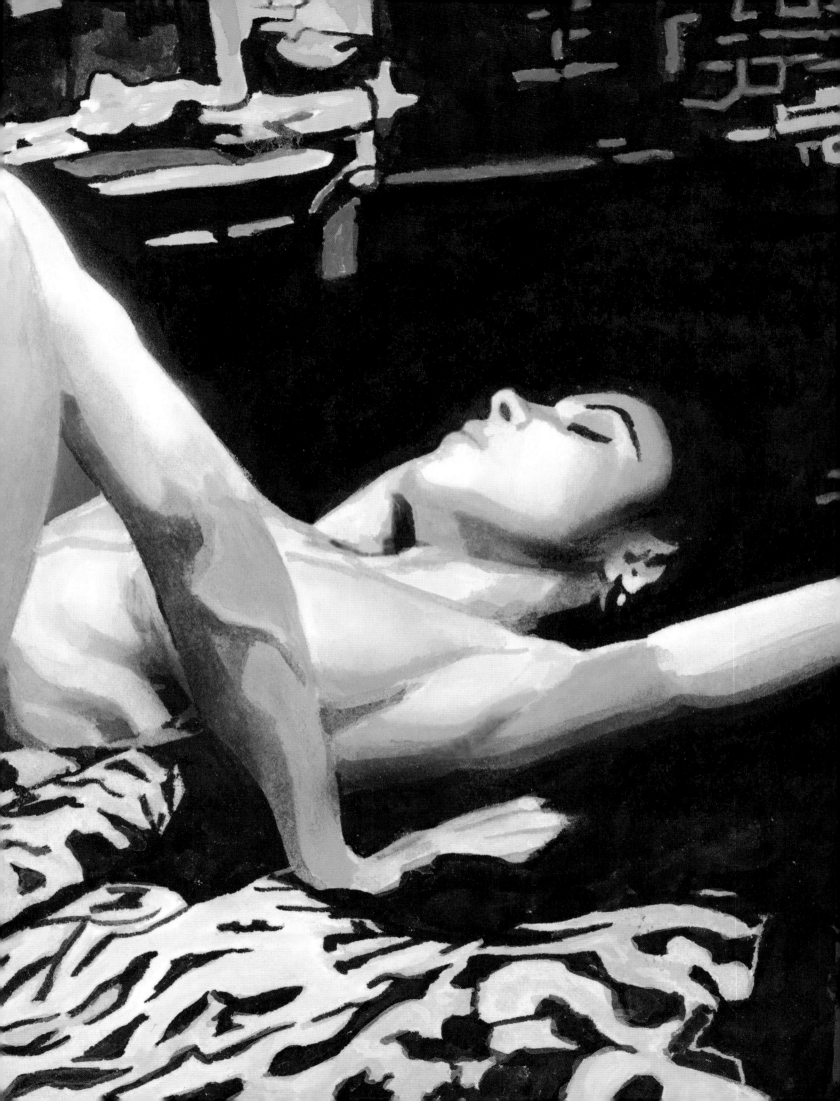

Even though the work displayed herein covers the last 5 years of my career, I have been drawing & painting for as long as I can remember. This overview of my technique is something that I've developed over time.

Lady Kayla II.

Stage 1) The Grid: This is the most critical stage, for if your drawing is off, the painting will be seriously flawed. In order to draw well, you have to develop your eye to accurately interpret what you are seeing and then be able to transfer it onto a surface (wood panel). I employ the grid technique because I find it to be a great tool in achieving an accurate transfer. When photographing the models, I make sure to have enough lighting so I don't need to use a flash. The flash can sometimes flatten out the skin tones. It is very important that you measure your boxes carefully so that your photo reference and your painting surface will have the same number of boxes and that the boxes between the two are all in the same ratio. I choose to use thread to construct my boxes (I.E. a floating grid). This way I don't have all those unwanted pencil lines to erase when I finish my drawing. Make sure you study each box individually and observe the negative space (background) as much as the positive space (figures) when you draw. Once I remove the grid I then further define the drawing anatomically not only to compensate for camera distortion, but also to idealize the figures.

Stage 2) The Inking: In this stage I ink a black line over my pencil drawing with a thin brush. In certain cases as in the bound girl's pink shirt, I choose to use colored ink in order to more accurately reflect the material I'm to paint. Essentially, I'm still using oil paint, I've just diluted it into a liquid consistency by using alkyd resin as my binder & odorless mineral spirits as my solvent. When inking, it is important to be conscious of not only your hand but also of your breathing. For instance, if I'm going in to paint an eyelash, I will most likely be holding my breath or exhaling through the entire stroke. Accuracy is essential here for the latter stages to work.

Stage 3) The UnderPainting: During this stage I am blocking in with a bigger brush the major forms in the painting. For the background, I've laid out a pattern of green & black in an attempt to complement the movement in the foreground. When rendering the figures I prefer to go in with the heavy blacks first before applying the midtones & lights (I.E. Lady Kayla's latex apparel).

Stage 4) The Air-brushing: In applying the lights & midtones, I use an airbrush. Whether I'm airbrushing over an unpainted area of panel or softening up brushstrokes from my underpainting, the airbrush is a great tool to add atmosphere to your work. I like to paint with at least four airbrushes during a session. This way I can work quickly and don't have to clean the fluid cup for each color change. It is important to carefully interpret not only the warm & cool aspects of each color but also where the color falls within the gray scale. One crucial tip to impart on airbrushing is don't over do it!

An over airbrushed painting often lacks weight & substance having no hard edges or texture. For the final touches in the painting I use a thin paint brush to reinforce my heavy blacks as well as applying the white highlights (I.E. Lady Kayla's eyes, latex, & earrings as well as the bound girl's teeth, eyes, and socks). Remember, try to have fun with it, 'cause the old adage is true: "It's 1% inspiration & 99% perspiration."

◀ 'LadyKayla II - The Punishment Due'
Oil on Wood Panel - 30cm.X 40cm. - 1999

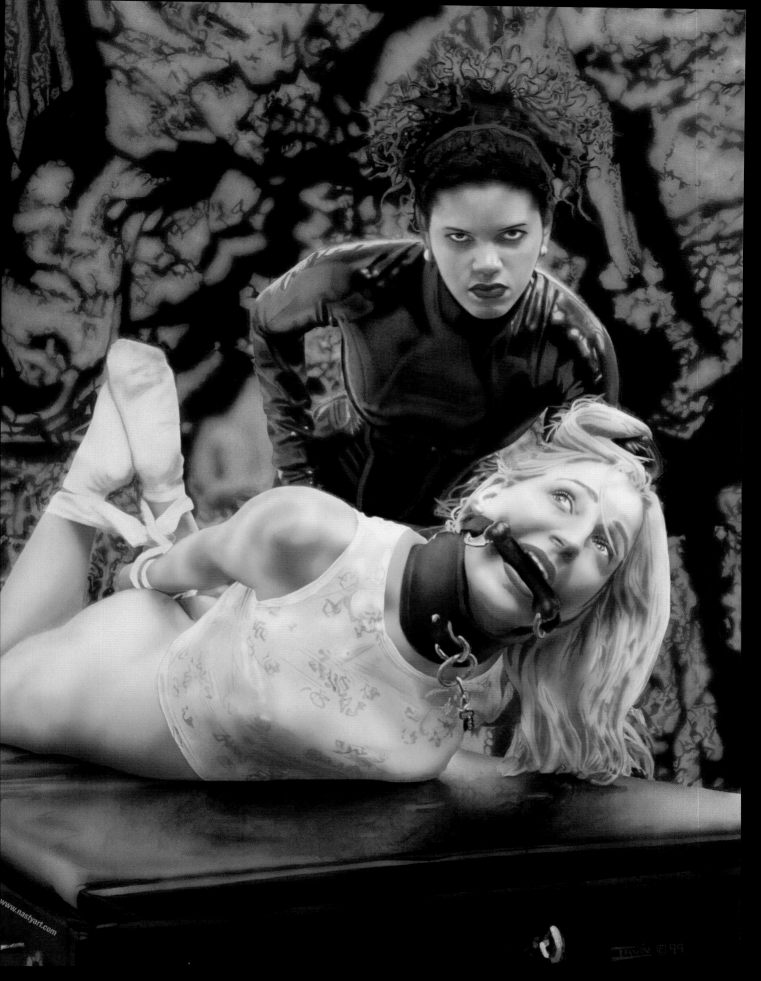

"Twisted temptation commands me to be evil thereby I stand for your redemption!"
-Lady Kayla, Domina Extrordinaire

39

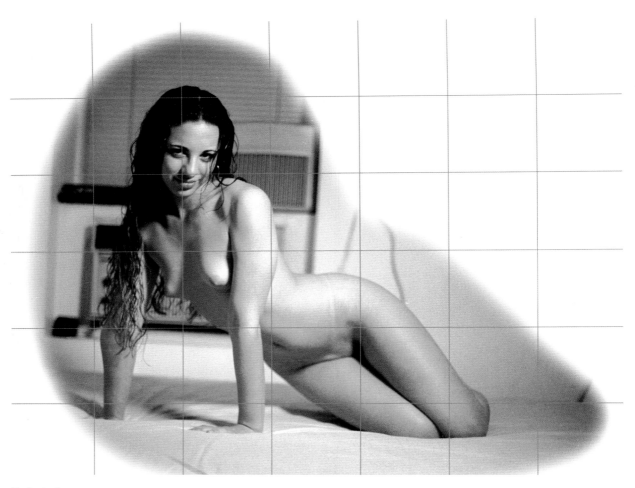

Ruby's Song:
Here is another example of the process I've just delineated above utilized in the stages displayed below.

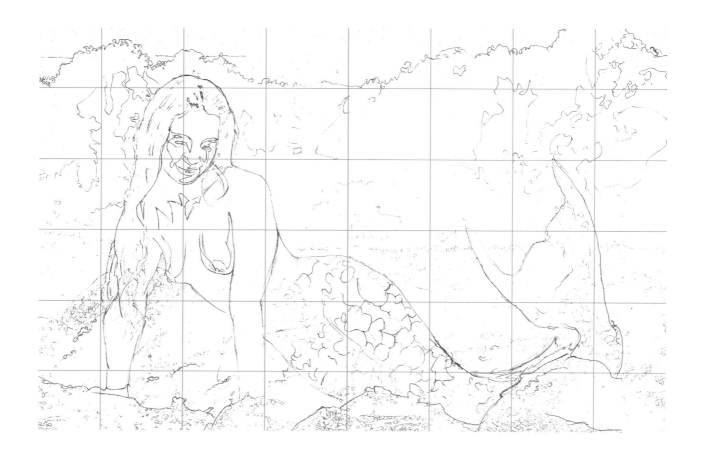

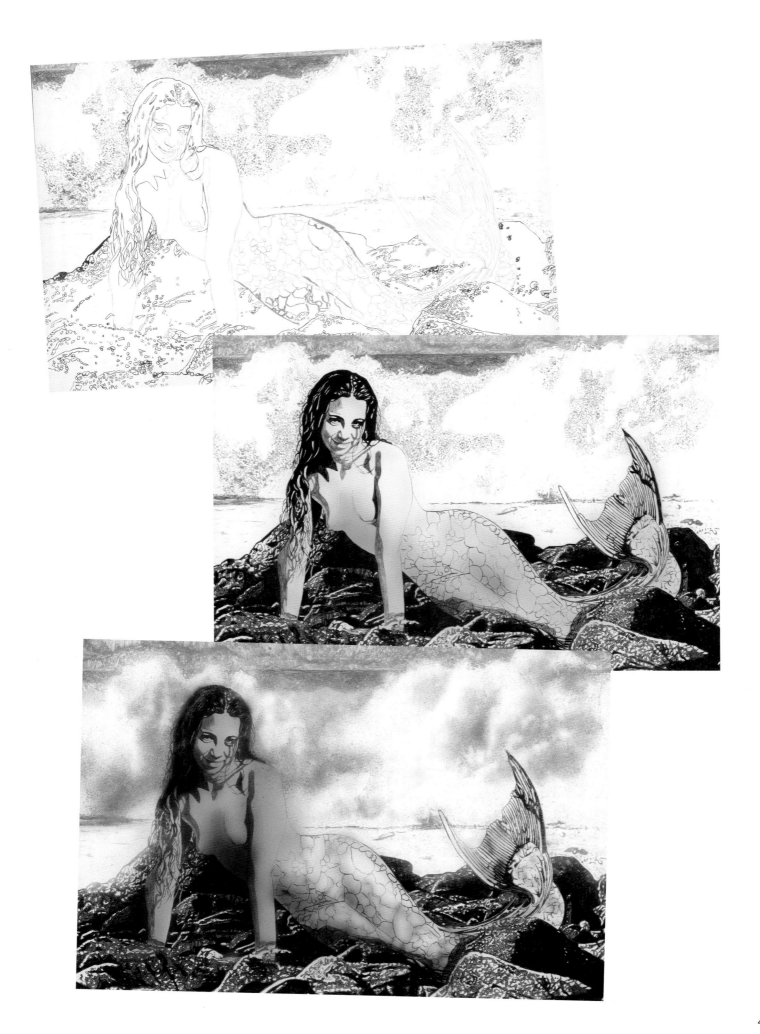

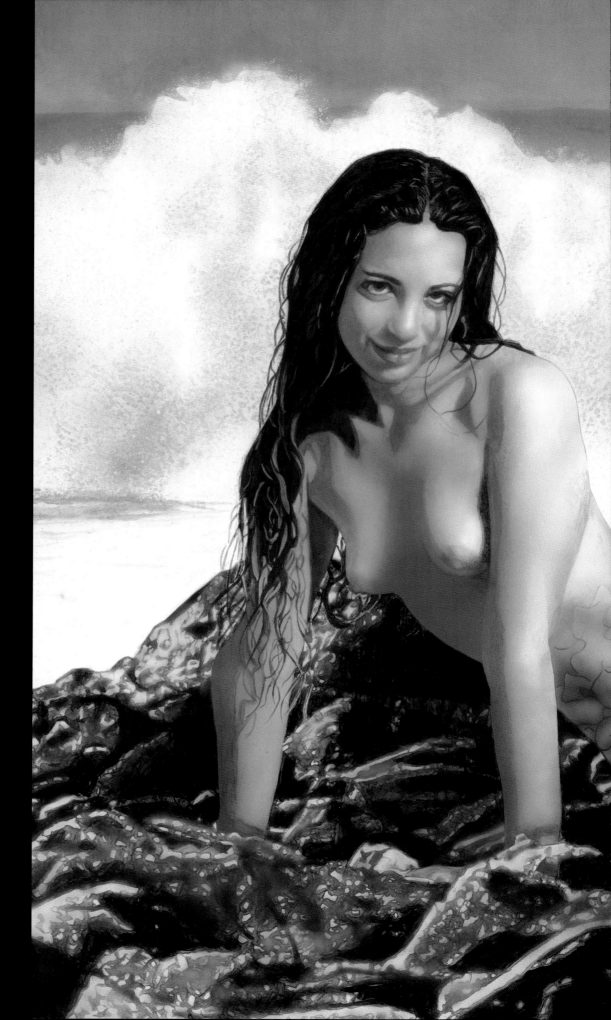

'Ruby's Song' Oil on Wood Panel – 40 X 30 cm. - 1999 This painting is dedicated to the loving memory of Ruby.

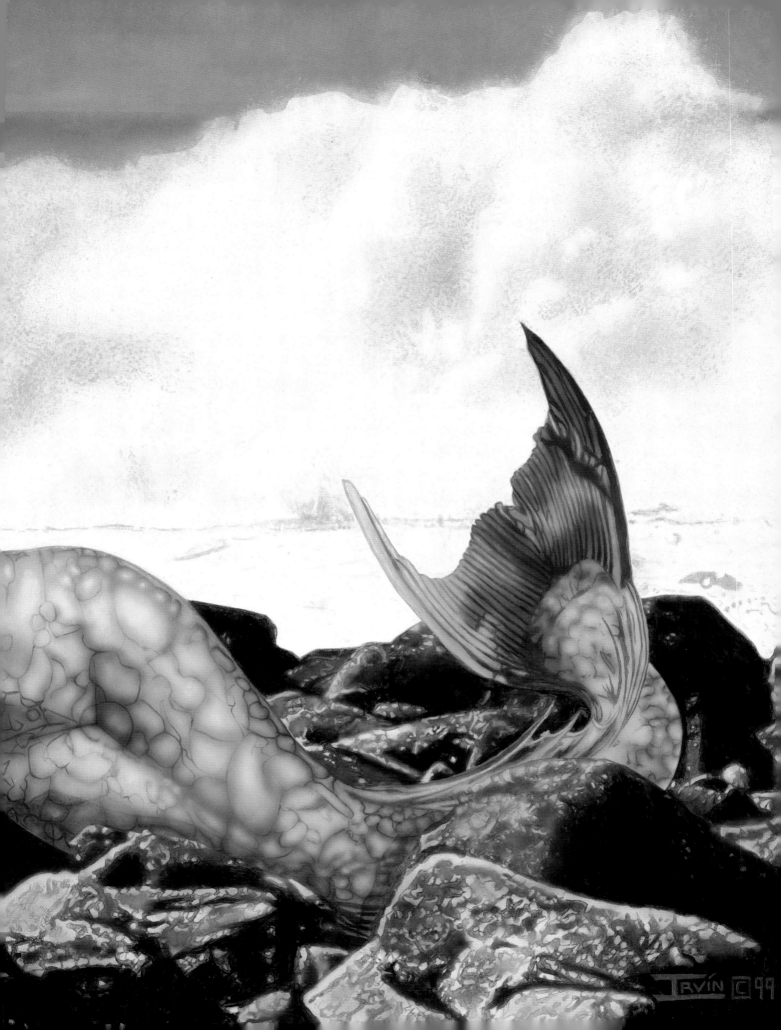

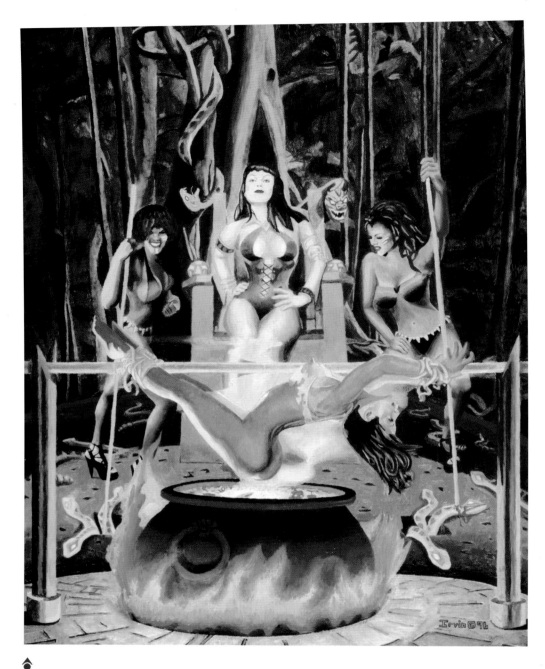

‘Barbeque Delight’ Oil on Wood Panel - 30 X 40 cm. - 1996

‘Big Butted Woman’ Watercolor on Paper - 27.5 X 37.5 cm. - 1997

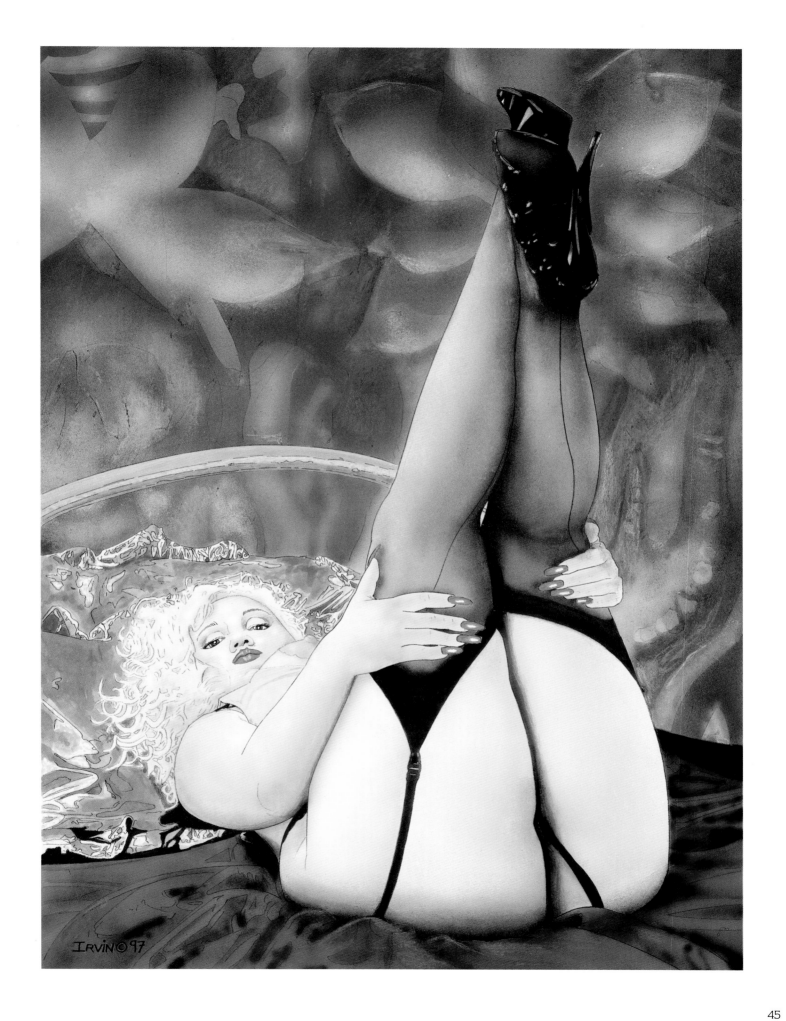

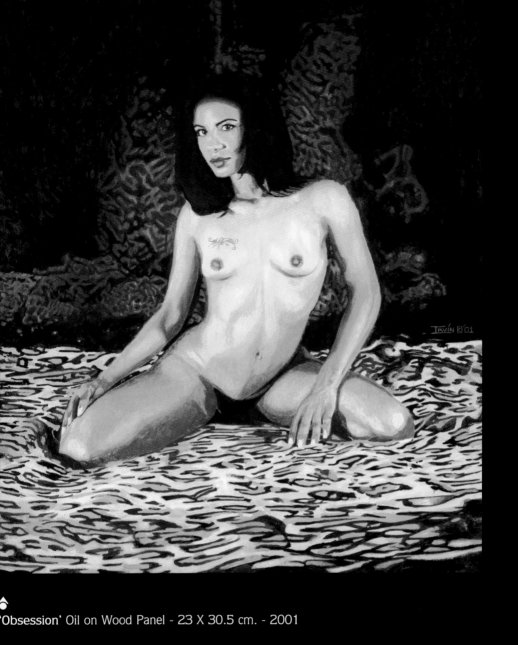

'Obsession' Oil on Wood Panel - 23 X 30.5 cm. - 2001

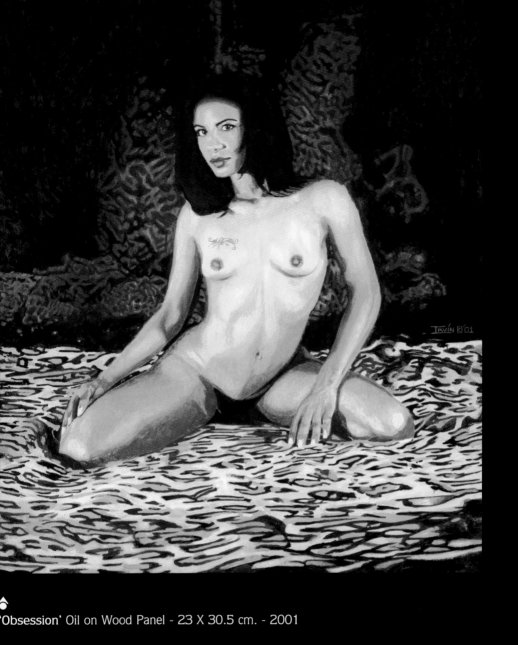

'Katie' Oil on Paper - 16.5 X 12.5 cm

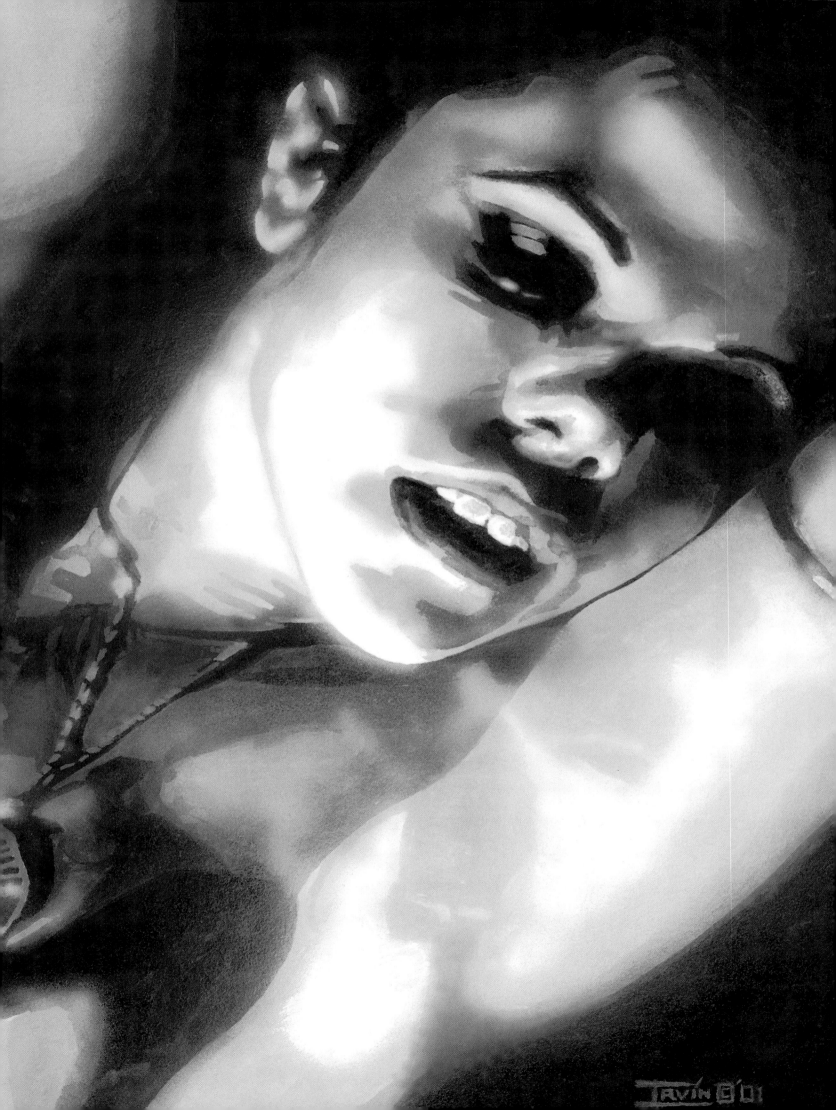

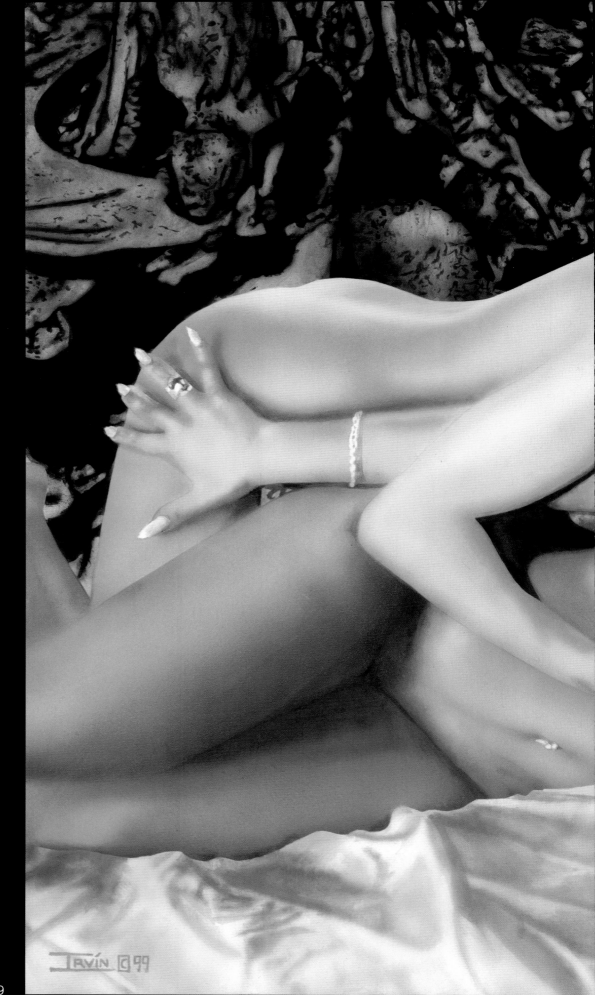

'The Hunger' Oil on Wood
Panel – 30 X 40 cm. - 1999

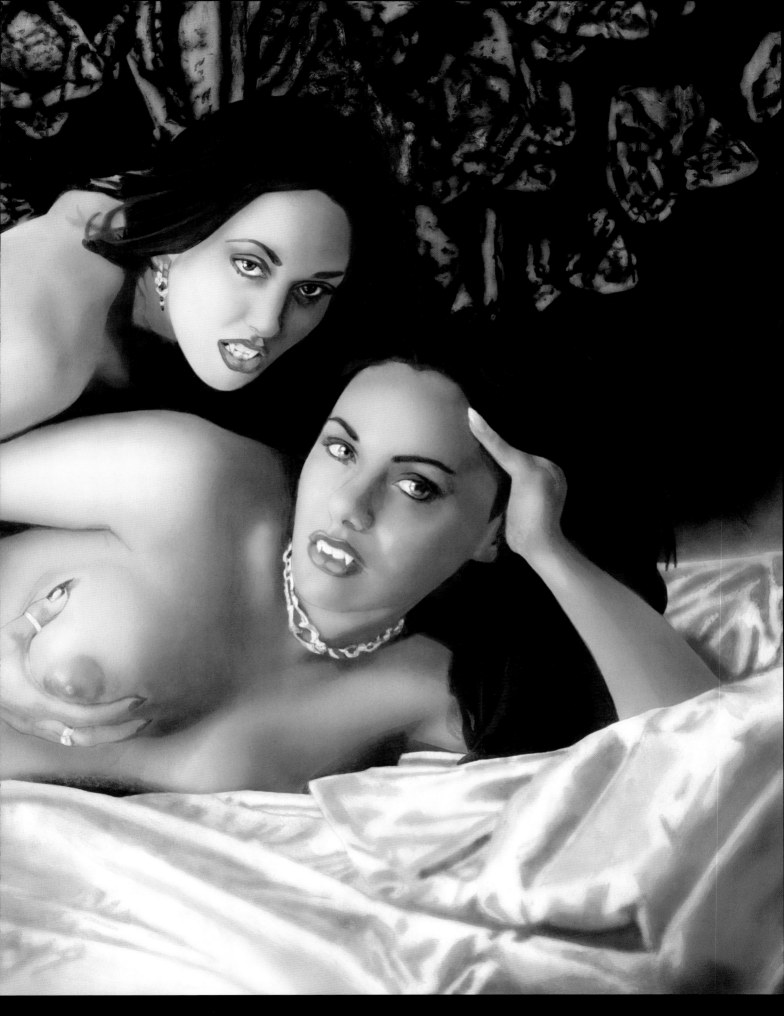

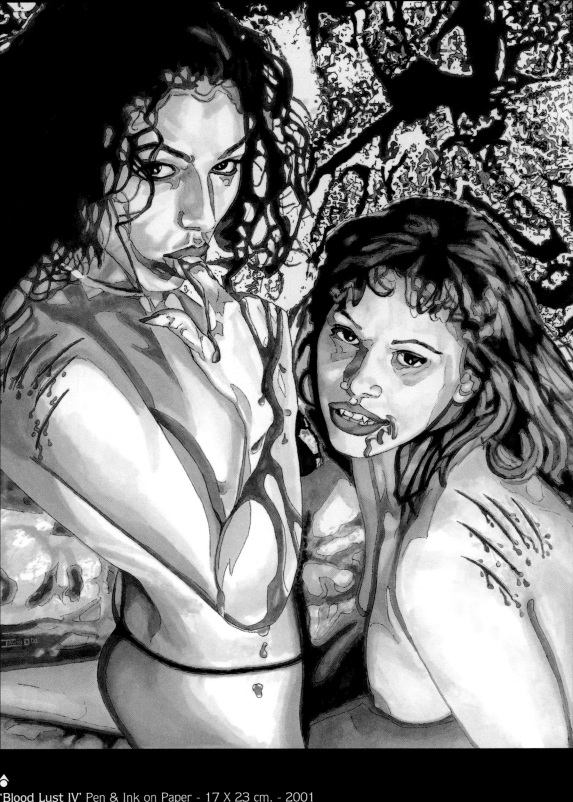

'Blood Lust IV' Pen & Ink on Paper - 17 X 23 cm. - 2001

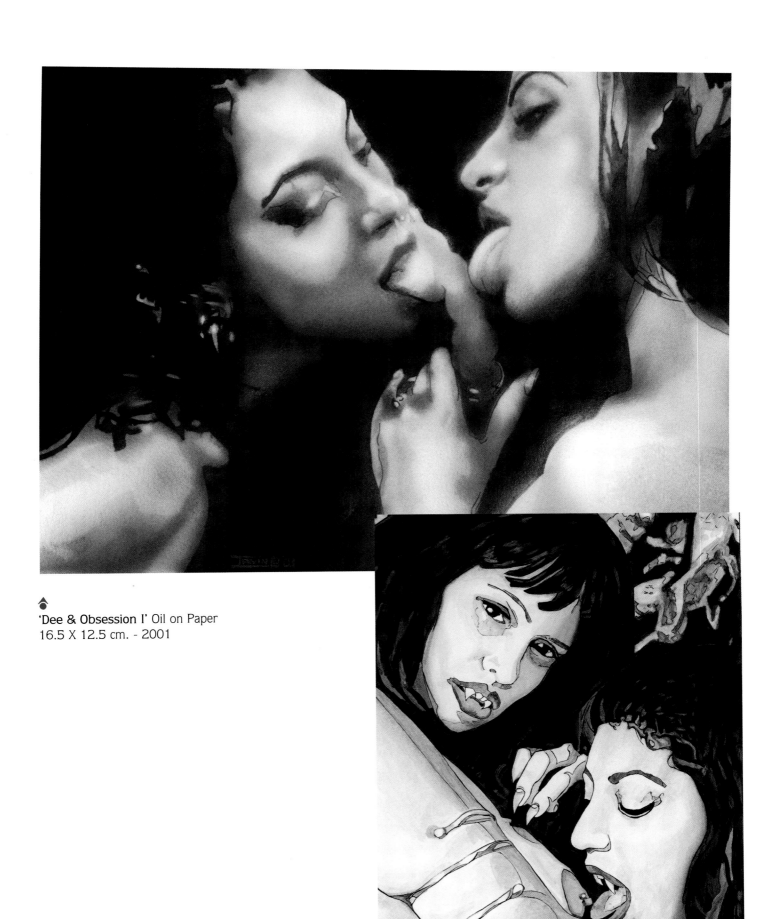

'Dee & Obsession I' Oil on Paper
16.5 X 12.5 cm. - 2001

'Blood Lust I' Pen & Ink on
Paper - 14 X 19 cm. 2000

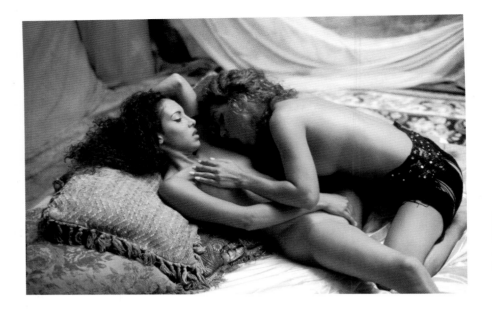

The Video Series:

NastyArt - Sensuous Strokes:

As Seen On In-Demand & Action Pay Per View. Irvin caught in action painting these luscious ladies broadcast in over 18 million potential homes in North America.

On these shows, Irvin persuades women from off the streets of Manhattan to come back to his studio & pose nude for a painting. Then we witness the action & delight in a lesbian sex-fest while these young naked beauties are immortalized on canvas. You can order the adult versions that were too hot for television at www.nastyart.com.

Stills By Robert Milazzo

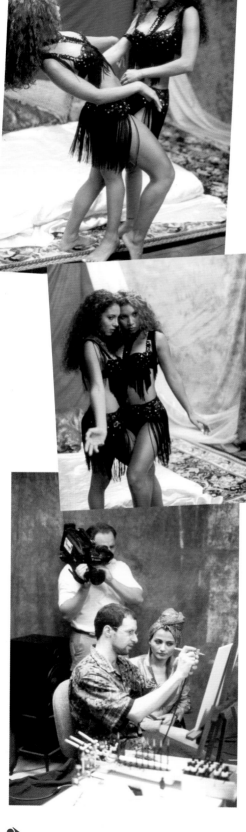

➤ Adult film star & Hustler cover girl Dee, checkin' on Irvin's progress

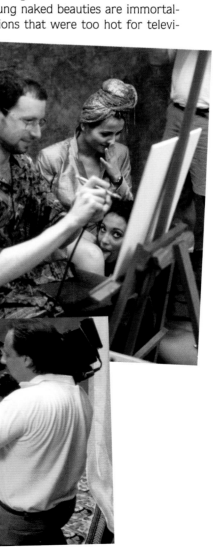

➤ 'Love on Dee Nile' Oil on Wood Panel
30 X 40 cm. - 1999

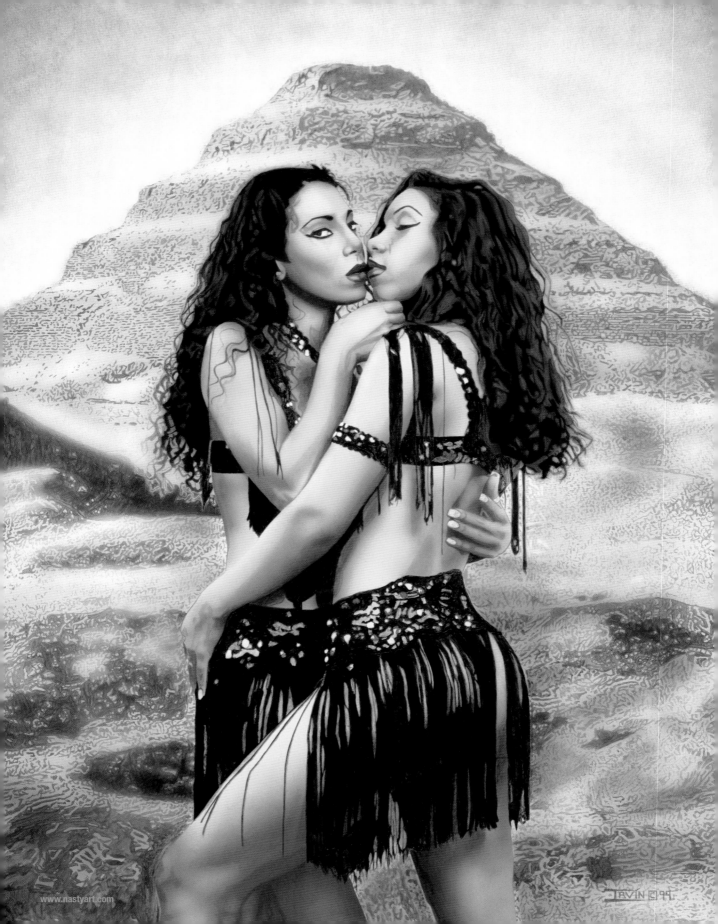

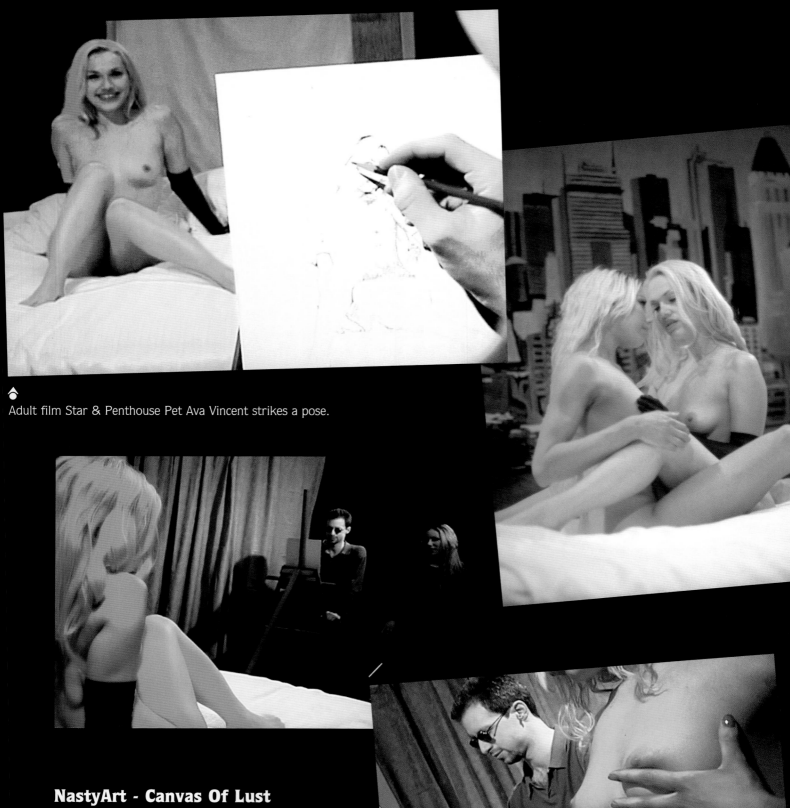

Adult film Star & Penthouse Pet Ava Vincent strikes a pose.

NastyArt - Canvas Of Lust

Stills By Steve Hillebrand & Irvin

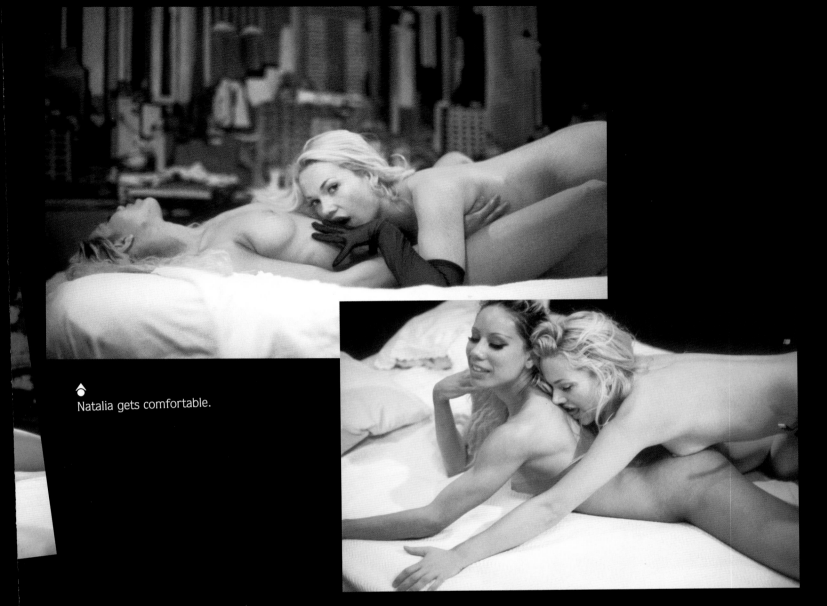

◆
Natalia gets comfortable.

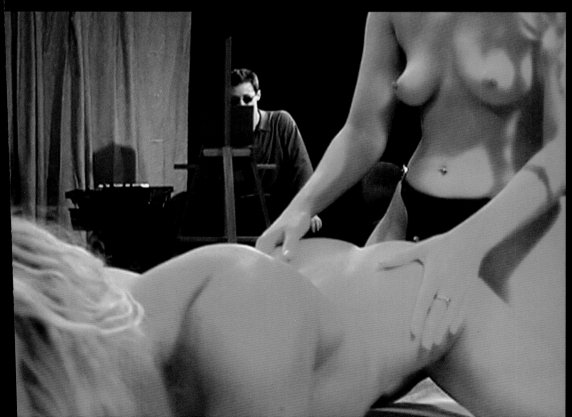

55

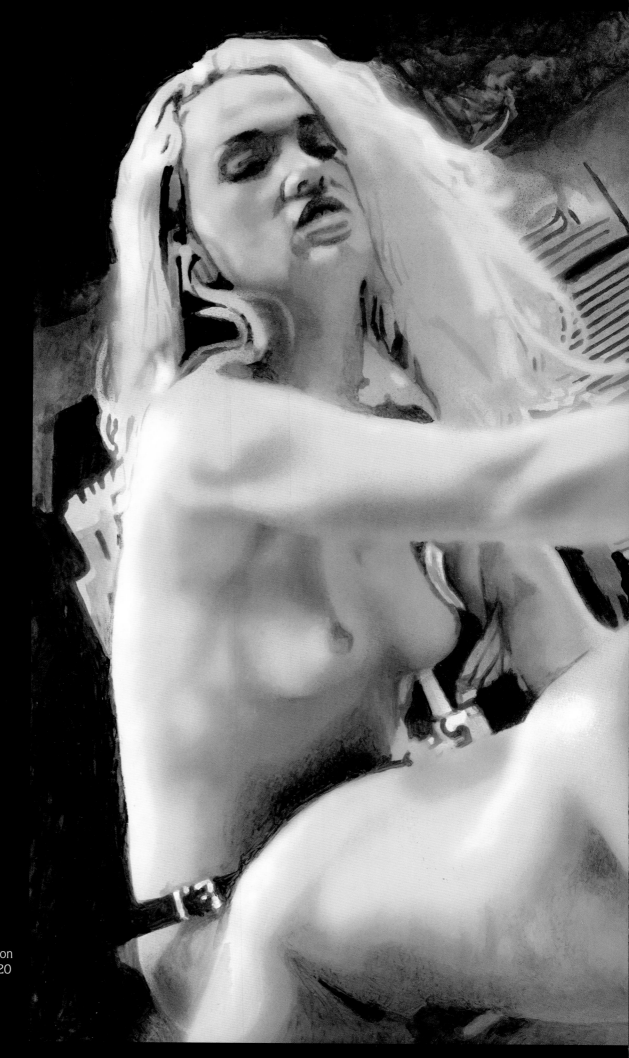

'Ava & Natalia II' Oil on
Wood Panel - 25.5 X 20
cm. - 2001

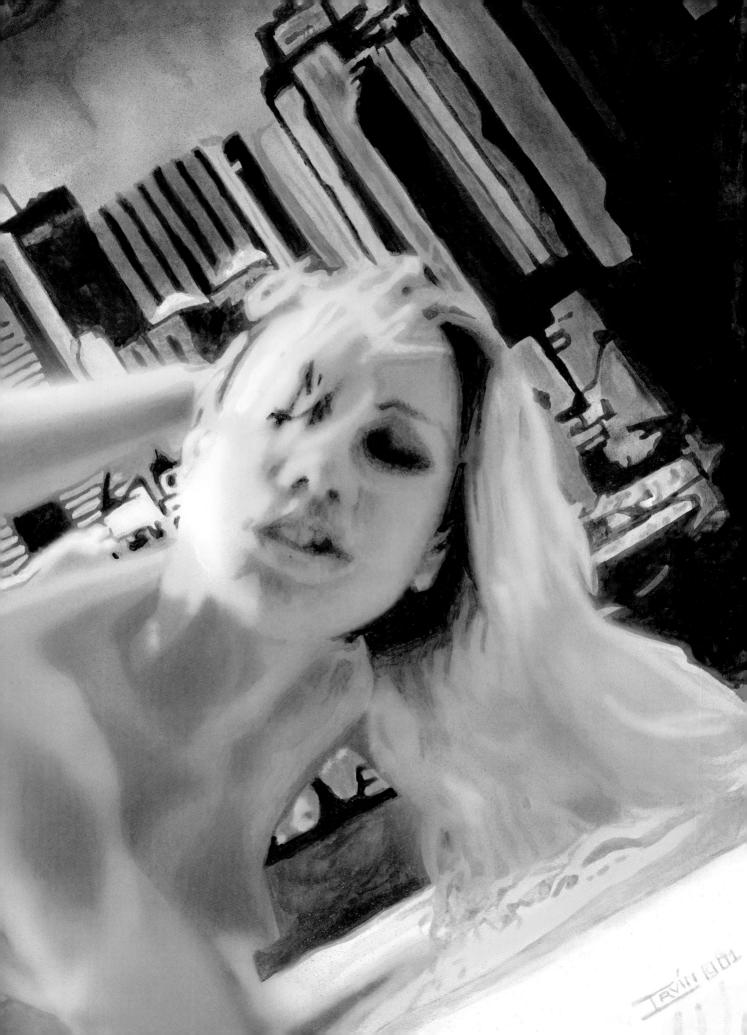

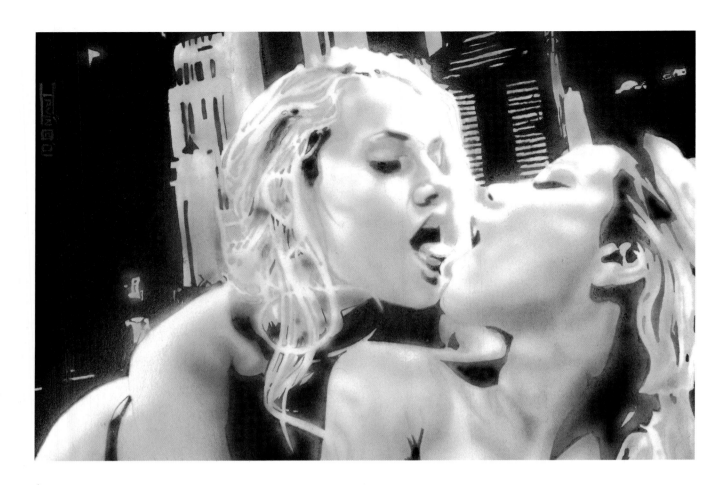

'Ava & Natalia I' Oil on Paper - 16.5 X 12.5 cm. - 2001

'Blue Light' Oil on Paper - 16.5 X 12.5 cm. - 2001

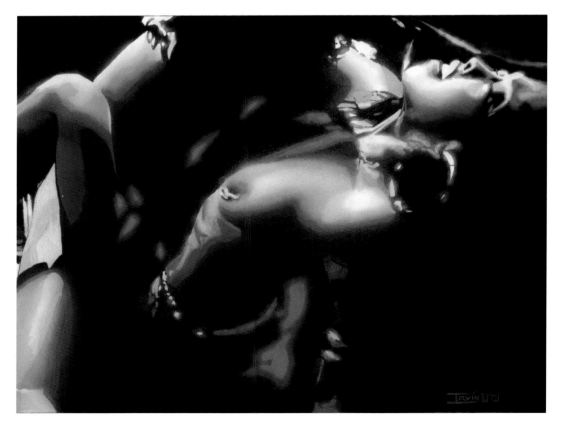

'Deception' Oil on Wood Panel - 32 X 43 cm. - 2001

Following double page spread:
'Blood Lust II' Pen & Ink on Paper - 28 X 21 cm. 2001

58

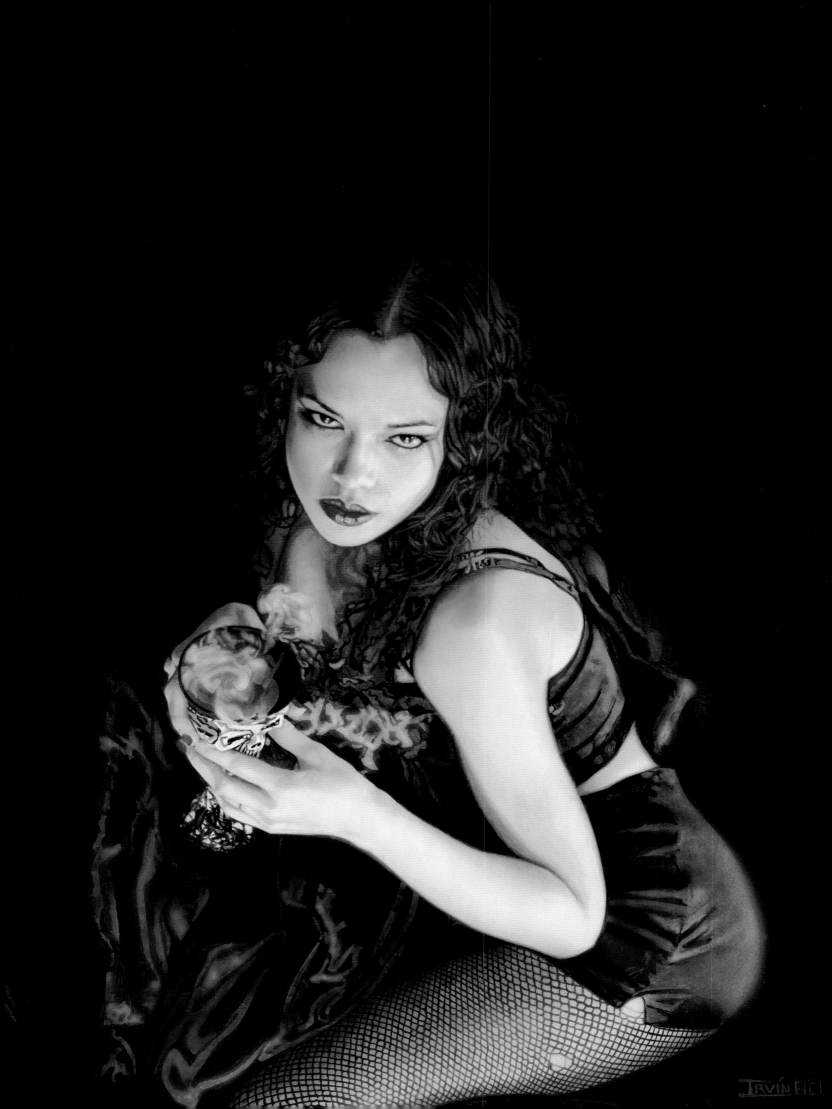

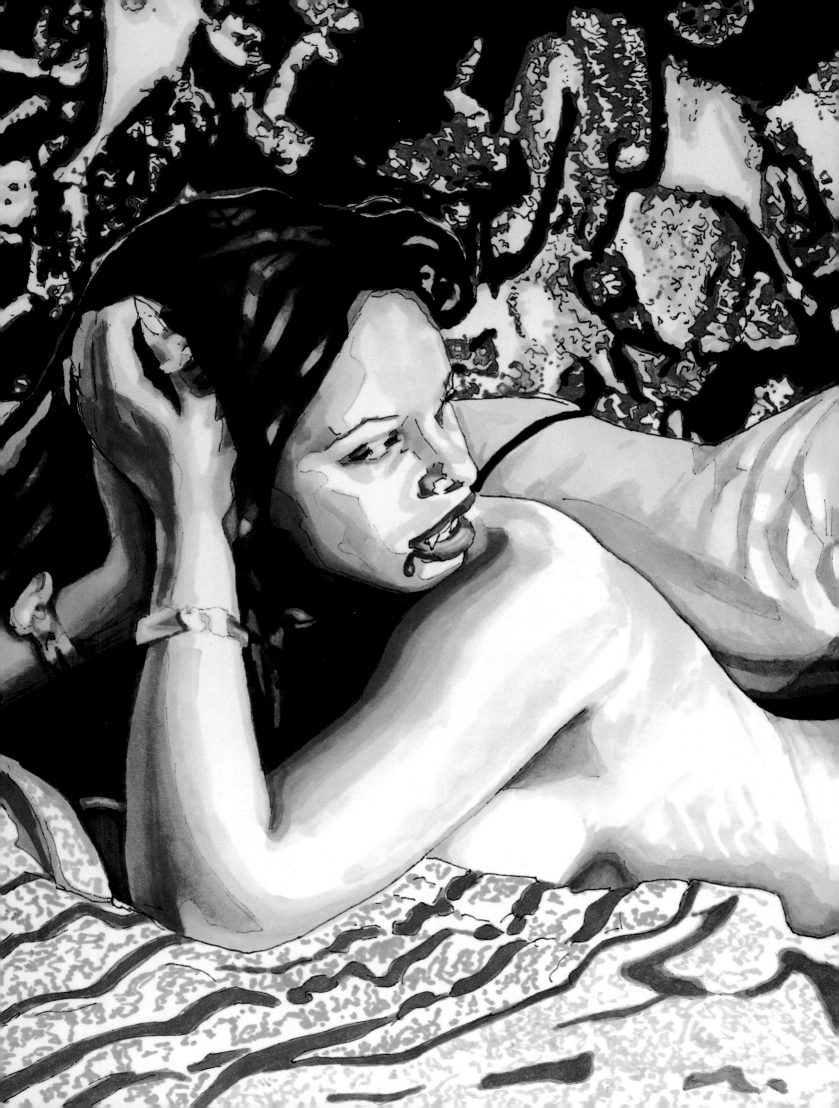

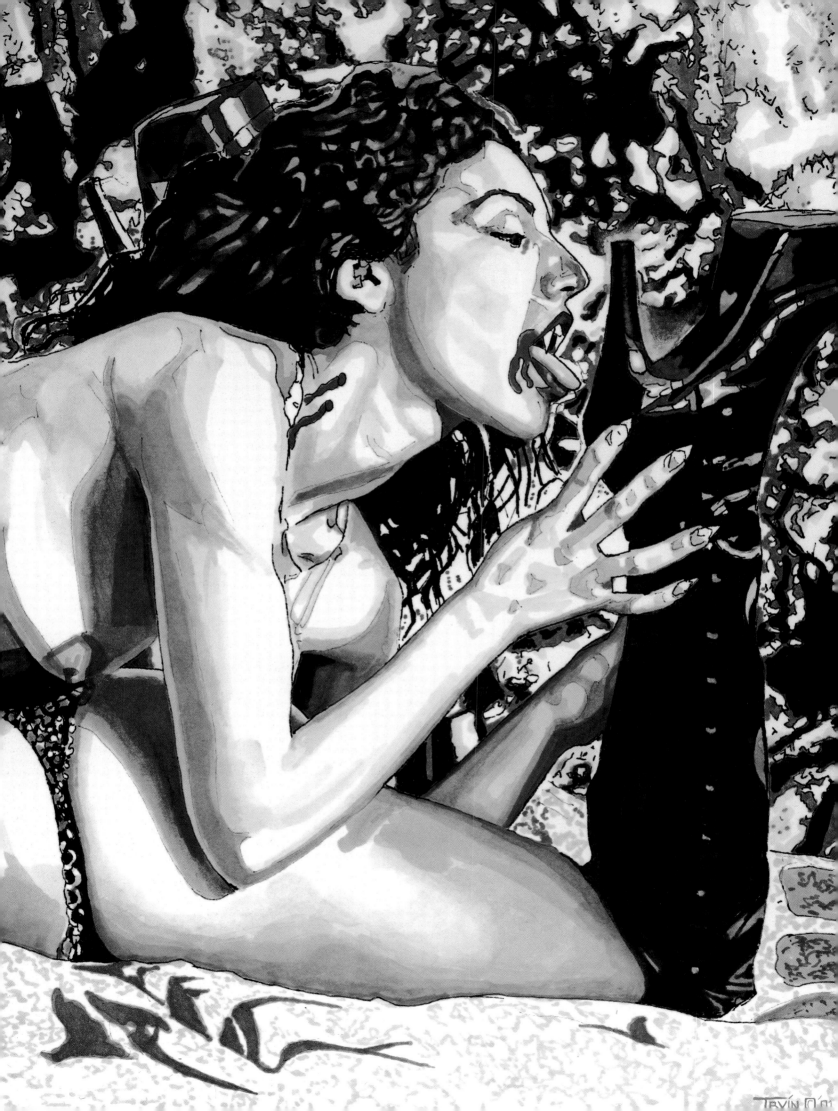

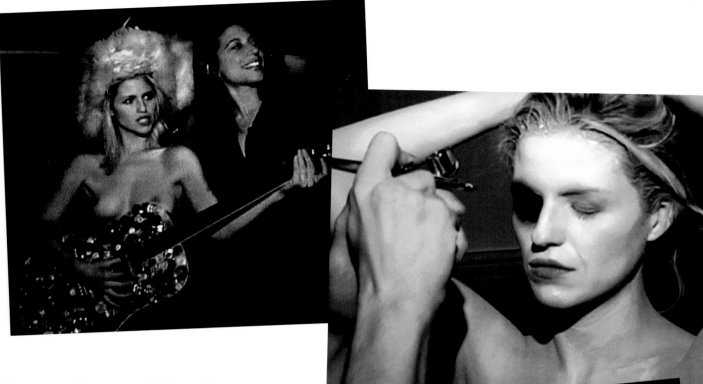

NastyArt - Fleshtones:

Ivy Supersonic, notorious feathered hat designer, invited Irvin to try his hand at some body painting at one of her scandalous private soirees. The lovely Just`In' Kase, in full body paint featured here as our lusty Zebra Woman, becomes transformed into a living work of art.
Stills By Steve Hillebrand & Irvin

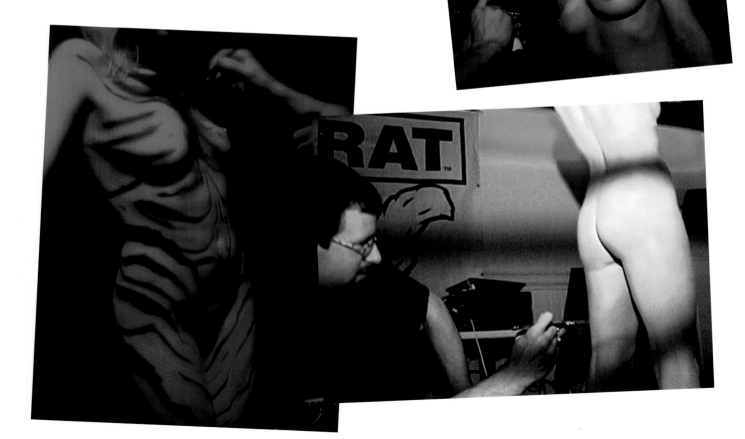

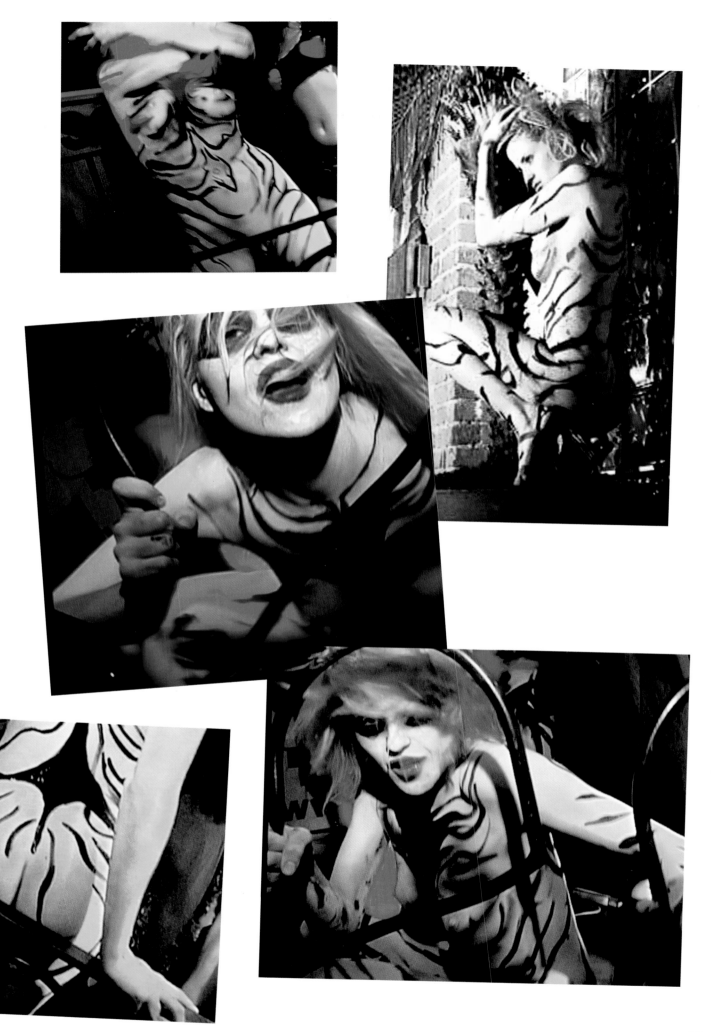

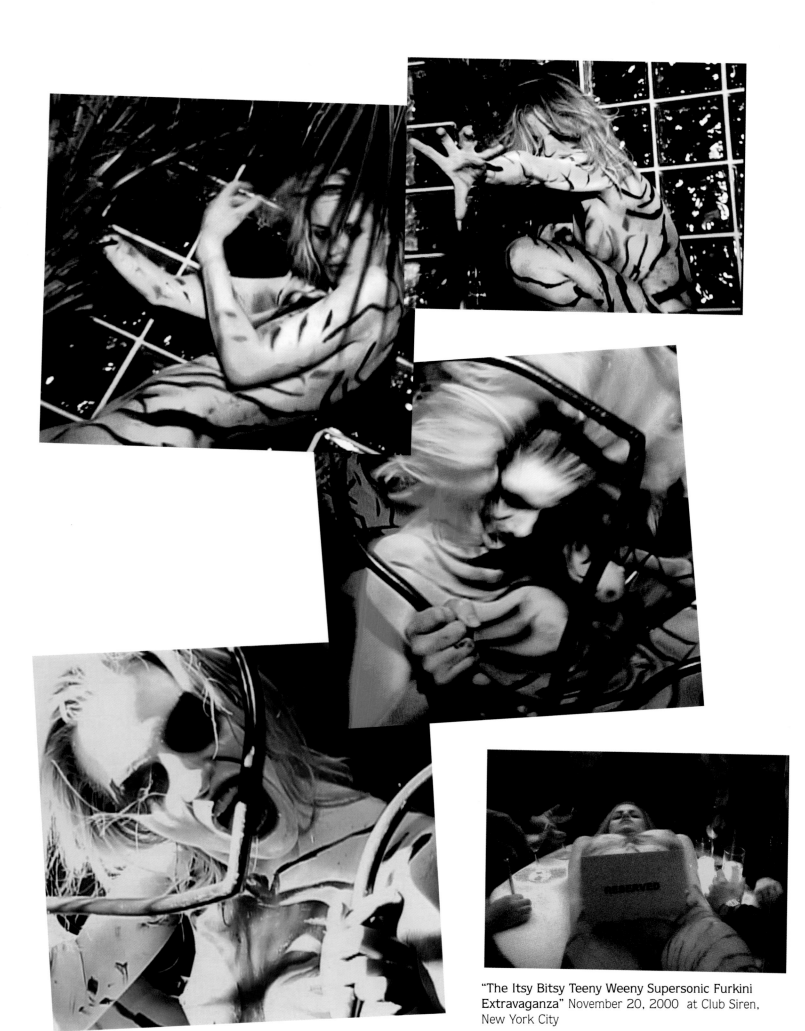

"The Itsy Bitsy Teeny Weeny Supersonic Furkini Extravaganza" November 20, 2000 at Club Siren, New York City